DN'T HOLD YOUR BREATH
NOTHING NEW FROM BRIAN EWING

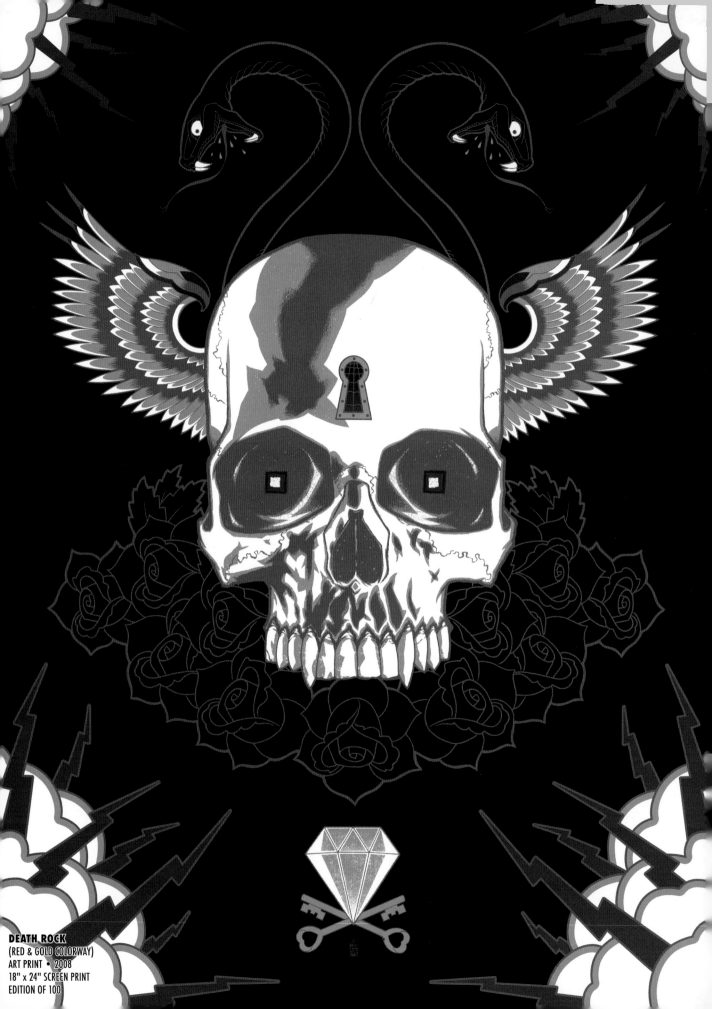

DEATH ROCK
(RED & GOLD COLORWAY)
ART PRINT • 2008
18" x 24" SCREEN PRINT
EDITION OF 100

DON'T HOLD YOUR BREATH

NOTHING NEW FROM BRIAN EWING

FOREWORD BY KEVIN LYMAN

- **WEAPONS OF CHOICE:** BLACK SKETCHBOOK, PENCIL, WINDSOR & NEWTON SERIES 7 #2 BRUSH, PH MARTIN'S BLACK STAR HICARB INK, MICRON #5 & #8 PENS CHEAP ELECTRIC ERASER, STRATHMORE SERIES 500 2 PLY BRISTOL, EPSON GT-20000 FLATBED SCANNER, ILLUSTRATOR CS3, PHOTOSHOP CS3, MAC COMPUTER

- **DRINK OF CHOICE:** COFFEE, BEER, JAMESON

- **WATERING HOLE OF CHOICE:** THE B SIDE · 204 AVENUE B · NEW YORK, NY 10009

- **MUSIC OF CHOICE:** NICK CAVE, MISFITS, IRON MAIDEN, ALEXISONFIRE, FINCH, BOUNCING SOULS, ELLIOTT SMITH, ANYTHING MIKE PATTON, THE MELVINS, ICED EARTH, BEASTIE BOYS, ATMOSPHERE, BRAND NEW, TAKING BACK SUNDAY, THE ACCUSED, THE DAMNED, FLOGGING MOLLY, DROPKICK MURPHYS, ELVIS, NIN, JOHNNY CASH, GASLIGHT ANTHEM, JESUS LIZARD, HELLACOPTERS, METALLICA, FUGAZI, BUZZCOCKS, MGMT, ANYTHING BILLY CHILDISH, WHITE STRIPES, THE ZEP, KYUSS, SLO BURN, QOTSA, ALKALINE TRIO, ANYTHING RELEASED ON MAN'S RUIN, NATAS, FOO FIGHTERS, ANGELO BADALEMENTI, RFTC, NIGHT MARCHERS, HOT SNAKES, NACHTMYSTIUM, BERNARD HERMANN, MONSTER MAGNET, FU MANCHU, BLUR, GORILLAZ, DESTRUCTION, THE CLIPSE, N.E.R.D., THE SPECIALS, OUTKAST, PIG DESTROYER, KANYE WEST, DRAGONFORCE, MY CHEMICAL ROMANCE, TIGER ARMY, LEONARD COHEN, HANK WILLIAMS I & III, SONIC YOUTH, THE CRAMPS, THREE BAD JACKS, DEMANDER, MORPHINE, RAMONES, CLASH, MILLENCOLIN, BOSSTONES, BOWIE, DJ SHADOW, THE KNIFE, BEIRUT, HOLD STEADY, BEAR VS SHARK, NEUTRAL MILK HOTEL, SEAWEED, GENERATION X, PHARCYDE, TURBONEGRO, DWARVES, (ANYTHING JASON DENZER, BILL AT RUSHMOR, ROSS STEINBERG, JUSTIN JEWETT, OR JOSH STANTON TOLD ME TO CHECK OUT), DANZIG, OPEN HAND, COHEED & CAMBRIA, P.O.S., ELECTRIC FRANKENSTEIN, HIGH ON FIRE, SUNNY DAY REAL ESTATE, JAWBREAKER, VOIVOD, X . . . PLEASE MAKE ME STOP!!!

DARK HORSE BOOKS

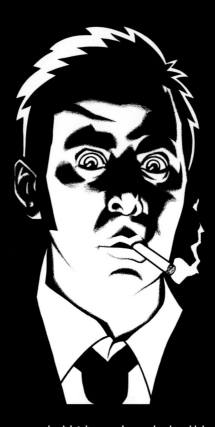

This book is dedicated to everyone who didn't listen to the people who told them they were going to fail.
And to the people who told me I would.

Adele Ewing, Kristi Ewing, Mike Richardson, Chris Warner, Kevin Lyman, Sarah Baer, Everyone at Dark Horse, Rich Black (aka Dick Negro), Frank Kozik, Coop!, Tara McPherson, Kat Bret, Norma V. Toraya (aka Biggie Norms, Jersey Slug Lady, Donut Genie), Andrew Bawidamann, Rev. Dave Johnson, (Uncle) Otto Zielke, Todd Waxler, Christine Karayan, The Troubadour, Joe Sib, Justin Jewett, Aaron Nunley, Rachel Miller, Kate Hiltz, Bryan Kienlen, The Bouncing Souls, Claudio Sanchez, Blaze James, Coheed & Cambria, Mackie Osborne, The Melvins, Matt Davies, Eddie Reyes, Adam Lazarra, Taking Back Sunday, Ashley Dechter, Hilary Zarycky, Josh Bernstein, Steve Chanks, Neil Shulman, Julie Grant, Becky Cloonan, Vasilis Lolos, Gigposters.com, Jermaine Rogers, Leia Bell, Jay Ryan, Pete Cardoso, Print Mafia, Scrojo, Munk One, Kevin Tong, Justin Hampton, Steve Somers, Warren Prindle, Elvis Suissa & The Three Bad Jacks, Woody Hinton III, Dave Crosland, Jason Knudson, Ross Steinberg, Sharon Ludtke, Amanda Daunis, Dan St. George, Brian Flynn, Rene LaFargue, Pete Mitchell, Cretins MC LA, Steve Horvath of D&L Printing, Pooka, Ruth Waytz, Alan Forbes, Moss, Justin McNeal, Sal Canzonieri, Dan Panosian, Jeff Johnson, Drink & Draw Social Club, Gene Ha, Bethany Paul & Graceland, Sivan Harlap, The B-Side, Miles Kerr, Mike & Tonya Sutfin, Luther Davis, Revolver Magazine, Royal Flush, The New Yorker, Max Bode, Harley-Davidson, Susanne Dawursk, Evan Cerasoli, Meltdown Comics, Skin & Ink, Spin Magazine, Staf Magazine, Josh Stanton, Sarah Stanton, Old Glory Barbershop, Cori Gadbury, Unkle Pigors, Buff Monster, Larry Flynt, Saralynne Lowrey, Cecelia Wingate, Johnny Thief & Seppuku Tattoo, Steven Parke, Secret Agent Salon, Mark Bubb, Matt Ash, Kevin Workman, Sean Healey, Jen Bennet, Dorothy Hascenecz, Keila Miranda, Brooke Kent, Jason Denzer, Alicia Denzer, Neil Pech, Mr. Podolske, Rev. Ciancio, Jeff Miracola, Front Magazine, Big Cheese, Amanda Davis, Ryan August, Mitch Putnam, Steve Horvath, Andy Diesel, Steve Donahue, Guitar World, Rica, Tanxxx, Shad Petosky, Vinnie Stall, Zander Cannon, Steve Niles, Tim Bradstreet, Thomas Jane, Big Brain Comics, Michael Drivas, Dillinger Four, Missy Suicide, Meow Suicide, John Miner, Erik Niles, Goldenvoice, Bill & Rushmor Records, MHSA, Scott Sorensen, Shannon Stockman, Kristin Cofer, Jef Parker (R.I.P.) & Collector's Edge, Gil Wadsworth, Heath Cofran, Rock Sound, Keenan Nichols, Katura Jensen, Jason Rosen, Richard Goodall Gallery, Ed Webster, Channel 4, the People Against Goodness And Normalcy, the ladies who broke my heart, ALL of the bands and promoters that took a chance and hired me to be a part of something bigger and affect the music scene. BIG thanks to all the people who shared their homes, couches, hearts, stories and booze with me. BIG BIG thanks to all of the people who enjoyed what I do, purchased it, spread the gospel, tattooed it on them, wrote about it, redrew it, and told me about it.

Publication Design: Brian Ewing
Back Cover Photo: Kat Bret

DON'T HOLD YOUR BREATH: NOTHING NEW FROM BRIAN EWING

DARK HORSE BOOKS
10956 S.E. MAIN STREET
MILWAUKIE OR 97222

DARKHORSE.COM

BRIANEWING.COM

FIRST EDITION: JULY 2010
ISBN 978-1-59582-314-4

1 3 5 7 9 10 8 6 4 2

PRINTED AT MIDAS PRINTING INTERNATIONAL LTD. HUIZHOU, CHINA

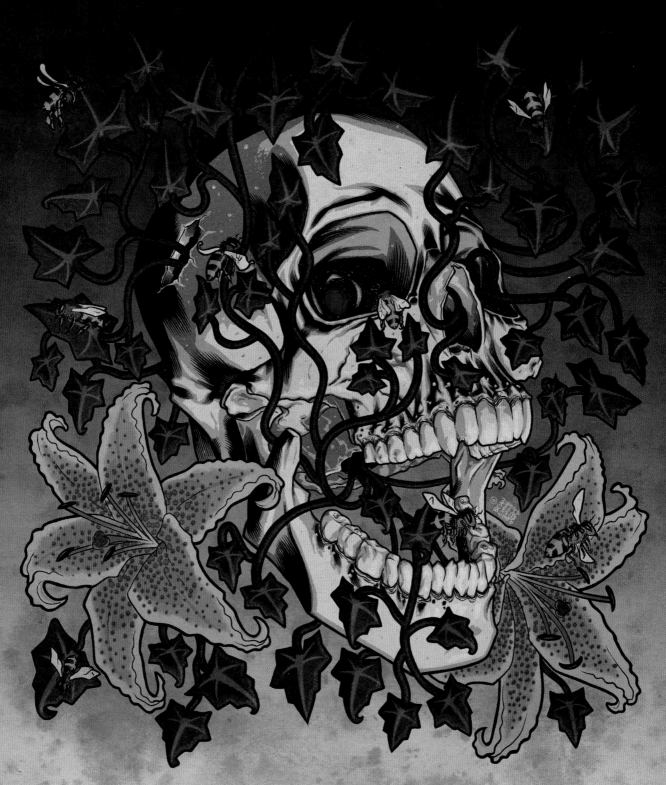

I WANT YOUR SKULL #5
MAGAZINE COVER • 2008
IWANTYOURSKULL.COM
OFFSET PRINT EDITION OF 1000

Ryan August publishes **IWYS** as a labor of love . . . for all things relating to everyone's appreciation of SKULLS. It's a 7" x 7" magazine filled with contributions from a ton of artists and worth checking out. I did the cover for #5 and an interview as well. There's a tutorial on my site detailing how I drew and inked this arthritis-inducing piece. Check it out.

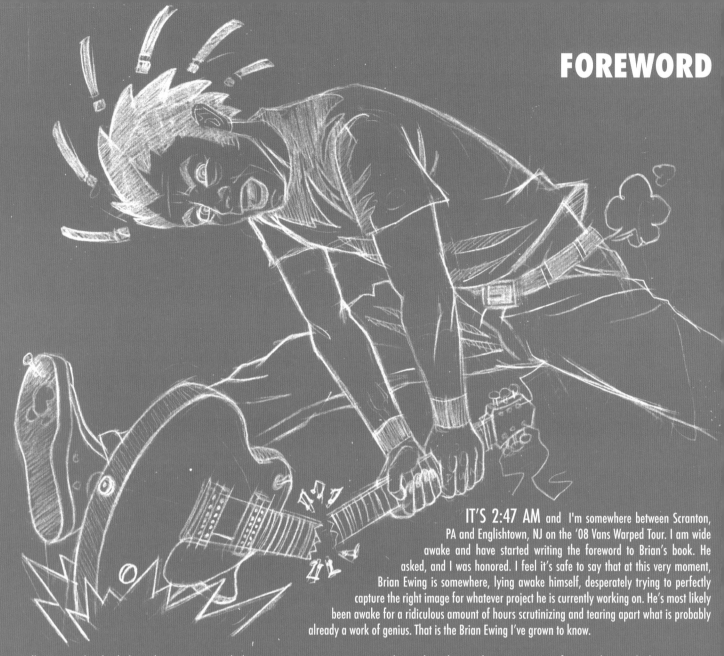

FOREWORD

IT'S 2:47 AM and I'm somewhere between Scranton, PA and Englishtown, NJ on the '08 Vans Warped Tour. I am wide awake and have started writing the foreword to Brian's book. He asked, and I was honored. I feel it's safe to say that at this very moment, Brian Ewing is somewhere, lying awake himself, desperately trying to perfectly capture the right image for whatever project he is currently working on. He's most likely been awake for a ridiculous amount of hours scrutinizing and tearing apart what is probably already a work of genius. That is the Brian Ewing I've grown to know.

Brilliance mixed with a little madness come to mind when I see a Brian Ewing piece. I use the word *madness* in the most reverent of ways. When you look at Brian's art you see something new every time. The various layers and nuances vary depending on your mood or where you are. This is one of the many things that makes Brian so important to the music, and more specifically punk, scene that he has belonged to for so long.

I also look at the way he has managed to maintain his creative control with each piece. It's something every recording artist wishes they could have. As an artist, he has been able to create work for both bands and corporate clients and has managed to maintain his credible look and feel while being able to work for some of the biggest companies in the US. This is a tricky navigation and something I have experience in with the line of work I'm in. It is a lot harder to achieve than one might think. Brian is able to dig into exactly what the band and the client hope to accomplish with the piece, and the end result has always been one of brilliance (mixed with a little madness). Whether he is creating a piece for an album cover, a club, or a car company, his brilliance shines through.

So when flipping the pages of this book, look at each piece twice and read Brian's subtext outlining what he was thinking at the time or the story behind each piece. It speaks volumes of his artistic abilities. When you're done looking at this book, put it down and pick it up again at a different time. You'll see something new every time. A piece will look different, mean something different. That's the brilliance of his work.

All the best to you, Brian. I have enjoyed working with you over the course of the years and am stoked to have had so many of your pieces involved in the Tour. I hope all the sleepless nights have been worth it. From one insomniac to another, I wish you many more anxiety-ridden nights.

—Kevin Lyman
July 2008
Somewhere between Scranton, PA and Englishtown, NJ

"Wow, Brian Ewing can actually draw! Y'know, with pencils and paper and brushes and ink and all that obsolete stuff!

"In my book that's a big deal, when everyone else seems to be satisfied with cold and sterile vector files, or 'appropriating' the work of others. How old-fashioned of Mr. Ewing to actually learn how to do something difficult, and continue to work at it until mastering the skill sets required. And how refreshing.

"Isn't it nice to look at those lovely lines and know they were created by a real live human being, not an algorithm? Maybe the robots won't take over and kill us after all."

—COOP
Rock Poster Artist
Fine Artist

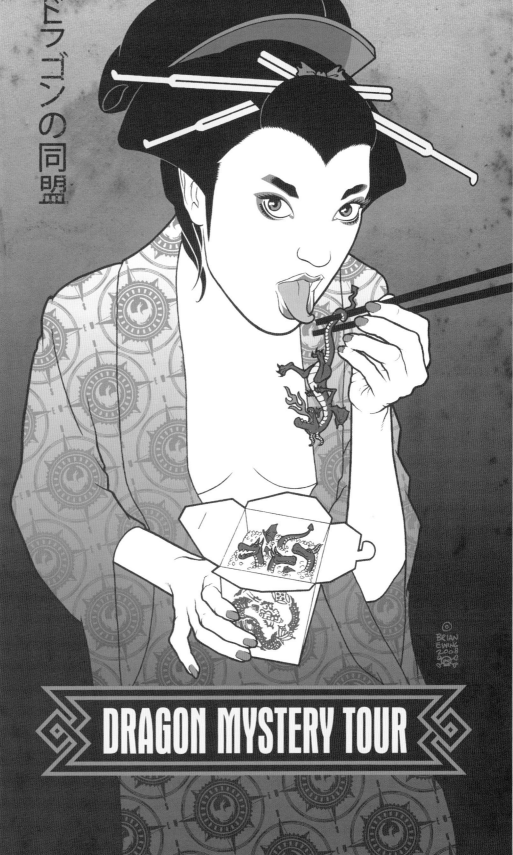

ドラゴンの同盟

DRAGON MYSTERY TOUR

Poster designed for the Dragon Mystery Tour. Scott Sorensen asked me (and two other designers) to come up with whatever we wanted and slap it onto a poster. The only rule was that it had to have the Dragon logo on it, and the text could not be changed. For the first one, Scrojo picked the colors, and we all designed our posters with the same color scheme. After that it was fair game. That approach made me try some new stuff and use different colors that I never thought would work well together. I like how it turned out. The color really made this what it is.

DRAGON MYSTERY TOUR
#1
TOUR POSTER • 2008
13" x 19" OFFSET PRINT

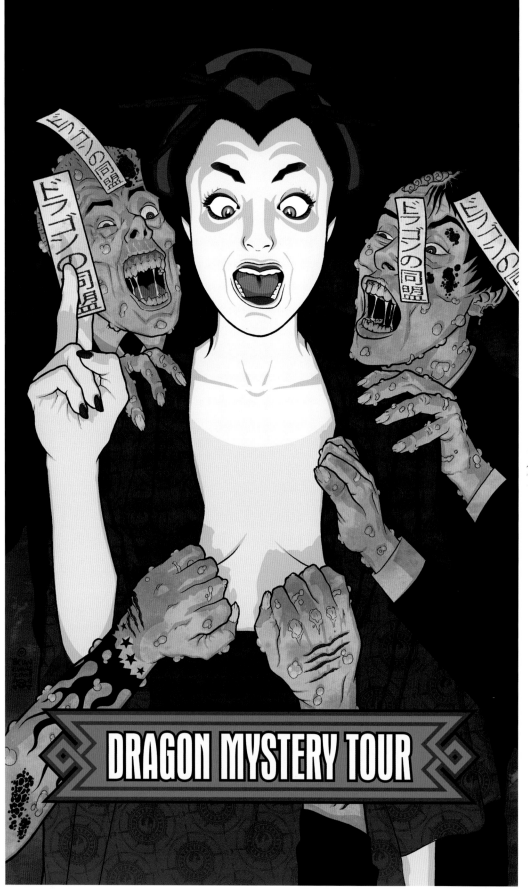

DRAGON MYSTERY TOUR #2
TOUR POSTER • 2008
13" x 19" OFFSET PRINT

The second poster for the Dragon Mystery Tour. I wasn't really sure what I would be doing. I just knew that I wanted to stick with my own theme and try to tell a loose story. So I chose geishas and (pervert) zombies. I like how the colors look Disneyfied. If you ever saw any of the *Chinese Ghost Story* flicks by Tsui Hark, then you know what I'm talking about.

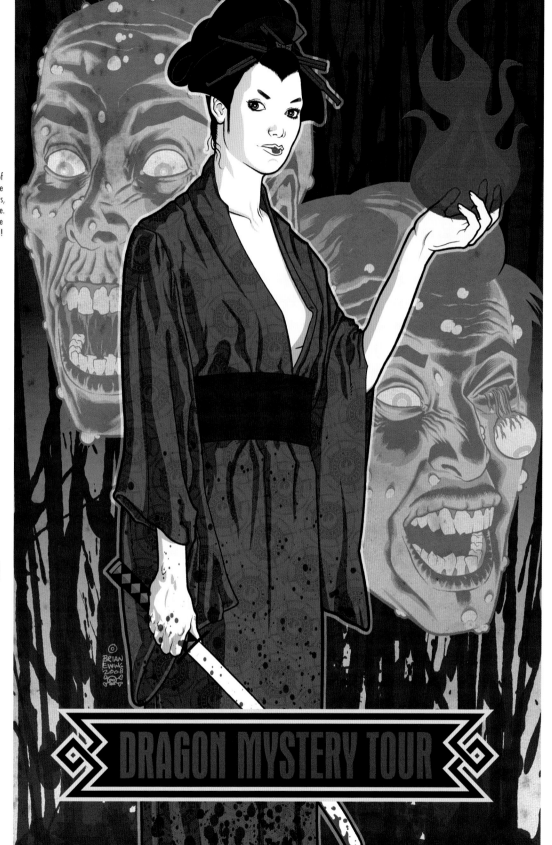

The third installment for the Dragon Mystery Tour. I started to get the hang of drawing geishas and what I could do in Illustrator with transparencies. I wanted to make the geisha character a Zombie Killer. Next best thing to being a zombie is getting to be the one who kills them. I think at this point a light bulb turned on, and now I'm wondering what else I can do with this character after the poster series.

DRAGON MYSTERY TOUR #3
TOUR POSTER • 2008
13" x 19" OFFSET PRINT

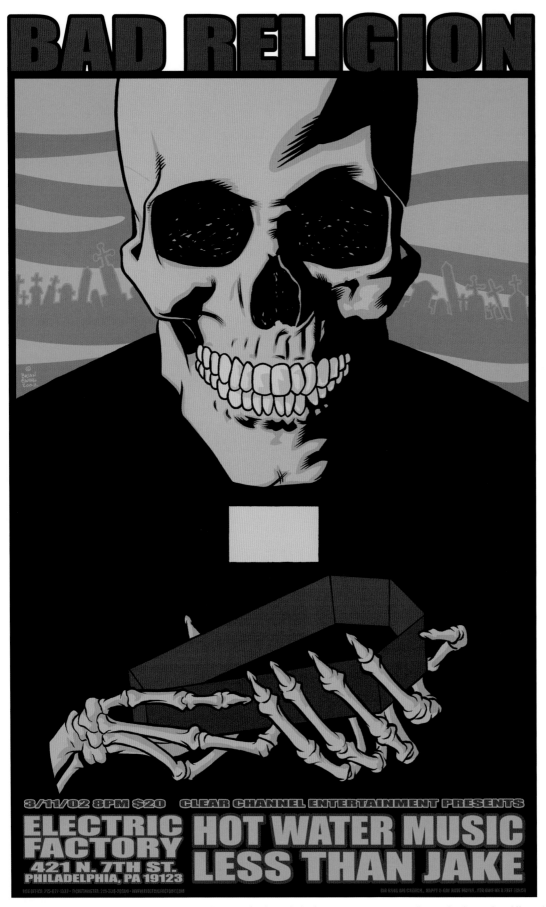

BAD RELIGION

BAD RELIGION
HOT WATER MUSIC
LESS THAN JAKE
ELECTRIC FACTORY • PHILADELPHIA • 2002
11" x 17" OFFSET PRINT • EDITION OF 300

Yeah, it's sort of a play on the band's name . . . sue me. I just really wanted to do something different than what I had seen done for the band. Drawing the bones of the hand was tough. Every anatomy book glosses over that part. I think I got most of it right.
I was introduced to Bad Religion in high school. (Yeah, I know . . . who wasn't?) I was making the transition from heavy metal to punk rock music, and this was one of the first bands that got me hooked.
Dave Mayer set me up with the job, so I felt obligated to put his name on the poster. Actually, he begged. I never got a free lunch from him.

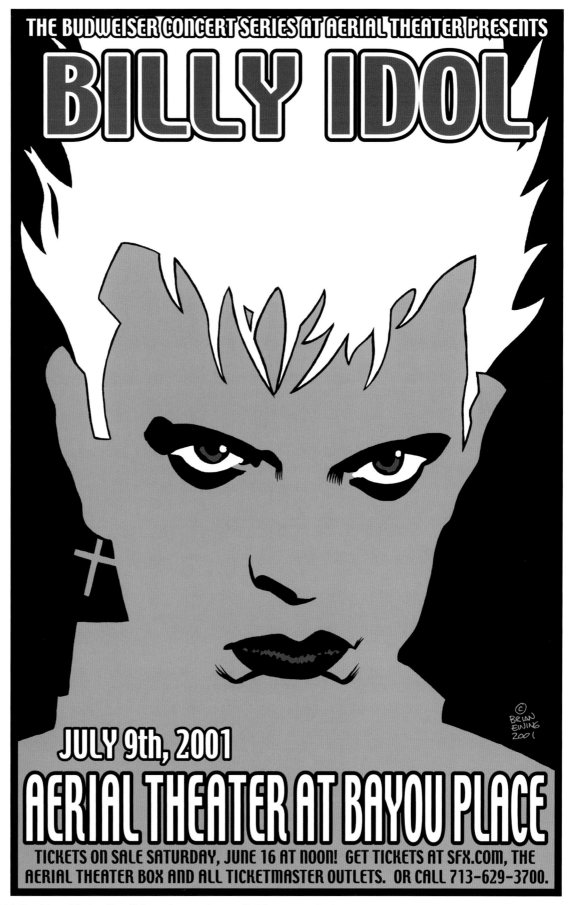

THE BUDWEISER CONCERT SERIES AT AERIAL THEATER PRESENTS

BILLY IDOL

© BRIAN EWING 2001

JULY 9th, 2001

AERIAL THEATER AT BAYOU PLACE

TICKETS ON SALE SATURDAY, JUNE 16 AT NOON! GET TICKETS AT SFX.COM, THE AERIAL THEATER BOX AND ALL TICKETMASTER OUTLETS. OR CALL 713-629-3700.

Jermaine Rogers hooked me up with this job. Dave Johnson helped art direct this for me. Two guys who were a big influence on me when I was starting out doing posters.

Whenever people ask what I do for a living, and I make the mistake of saying I'm a "concert poster artist" instead of the trusty title of "graphic designer." Then I hafta explain what a concert poster is, and still they look confused. Mostly because they never heard of any of the bands. I'm talking about adults . . . people older than me. So then I try to name off some bands that they might have heard of. Billy Idol is the only one they recognize. Pretty soon I'll be an adult and I won't know what the fuck the kids'll be talking about either.

BILLY IDOL
AERIAL THEATER • HOUSTON, TX • 2001
11" x 17" OFFSET PRINT • EDITION OF 200
18" x 24" THREE-COLOR SCREEN PRINT • EDITION OF 100

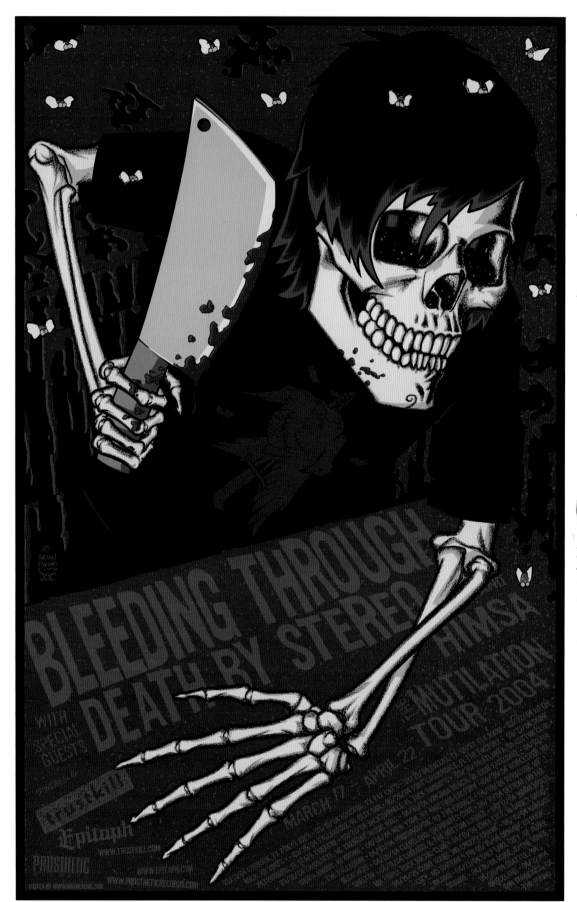

BLEEDING THROUGH
DEATH BY STEREO• HIMSA
TOUR POSTER • 2004
18" x 24" OFFSET PRINT • EDITION OF 250

Josh Grabelle (of Trustkill Records) hired me to do this tour poster for Bleeding Through, a band that is brutal as fuck. I had a lot of fun doing this one, because I was trying to break out of my habits with text and try something different. At the time, I was becoming a bit more proficient with Illustrator, too. It's kinda wonky for me to look at now. I still dig the drawing and the colors.

At the time there was a lot of debate amongst designers on gigposters.com — it seemed that birds were the new black. Every damn poster had a bird on it whether it needed one or not. At first it was cool but got stagnant because it was overused rather quickly. Anyway, this was my response to all the bird lovers. Don't get me started on squids or praying skeletons.

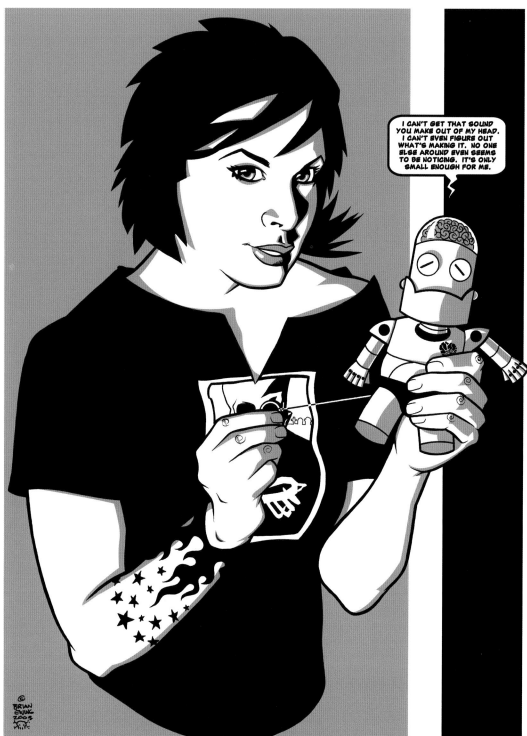

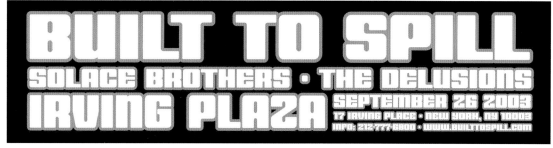

This was part of a series put together by Jermaine Rogers for Built to Spill. I was excited to be part of it, because BTS has been a favorite of mine for a long time. I've been a fan of Doug Martsch's music since his days in the Treepeople. Try to find a BTS album better than *Perfect From Now On*. I triple-dog dare you. That album is epic.

BUILT TO SPILL
SOLACE BROTHERS • THE DELUSIONS
IRVING PLAZA • NEW YORK • 2003
18" x 24" TWO COLOR SCREEN PRINT • EDITION OF 100

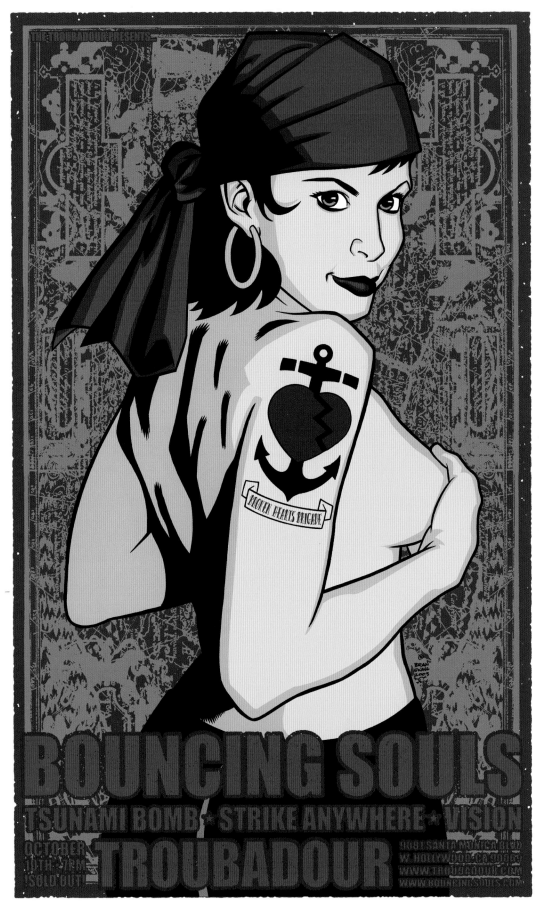

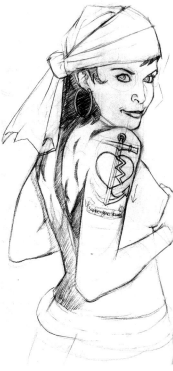

"Brian's band posters are more than just cool-looking artwork with lettering; he manages to capture the essence or spirit of the band with his imagery. From my perspective, this is a most important detail. Brian's work always rocks, and I feel lucky to have a nice collection of Bouncing Souls stuff with his name on it. My favorite is the hot pirate babe."

—Bryan Kienlen
The Bouncing Souls

BOUNCING SOULS • TSUNAMI BOMB
STRIKE ANYWHERE • VISION
THE TROUBADOUR • HOLLYWOOD • 2003
18" x 27" OFFSET PRINT • EDITION OF 300

My first poster for the Bouncing Souls! What a bunch of cool guys!! They are one of my favorite bands and always put on a great show. It meant a lot to get Bryan Kienlen's (bass player and artist of the band) approval at the show. The next day the venue's manager, Christine Karayan called me and said that the band had left some money for me. "What?" The venue had already compensated me (booze and guest list). The band appreciated that someone made a poster for them, so they took some of the money made from merch sales and gave it to me. Most bands don't do that!
I was stoked to see that they used this poster in their "Sing Along Forever" video. You can spot it hanging on the wall. They even do a close up of the pirate girl's tattoo from the poster. I was on Cloud 9 after seeing that video.

"During undergrad, my roommate and I started getting into screen printed and offset prints. Brian was the first artist we got into, and we actively sought out his prints, kind of like a gateway drug. Between the two of us, we had around twenty to thirty pieces of his art in our apartment before we graduated. I currently have a handful hanging in my office and a good deal in my apartment. My favorite piece is a Bouncing Souls/Hot Water Music show poster; it has a Valentines Day zombie theme — what's cooler than zombie love? I enjoy the colors, shading, and especially the imagery portrayed. It's always a conversation piece whenever someone new comes into the office."

—Neil Shulman
anchorlessrecords.com

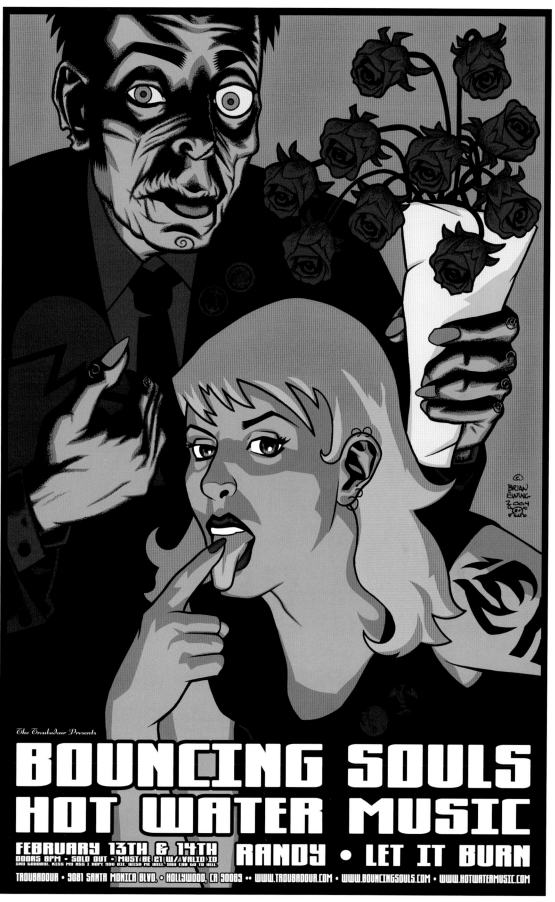

My second poster for the Bouncing Souls. I was trying to illustrate the song "Wish Me Well (You Can Go to Hell)." The Troubadour told me that the Souls requested I do the poster for the show. They didn't hafta ask — I was already working on it. I really wanted to draw a lovesick zombie and a cute punk-rock girl. Perfect for a Valentine's Day show.

BOUNCING SOULS • HOT WATER MUSIC
RANDY • LET IT BURN
THE TROUBADOUR • HOLLYWOOD • 2004
18" x 27" OFFSET PRINT • EDITION OF 300

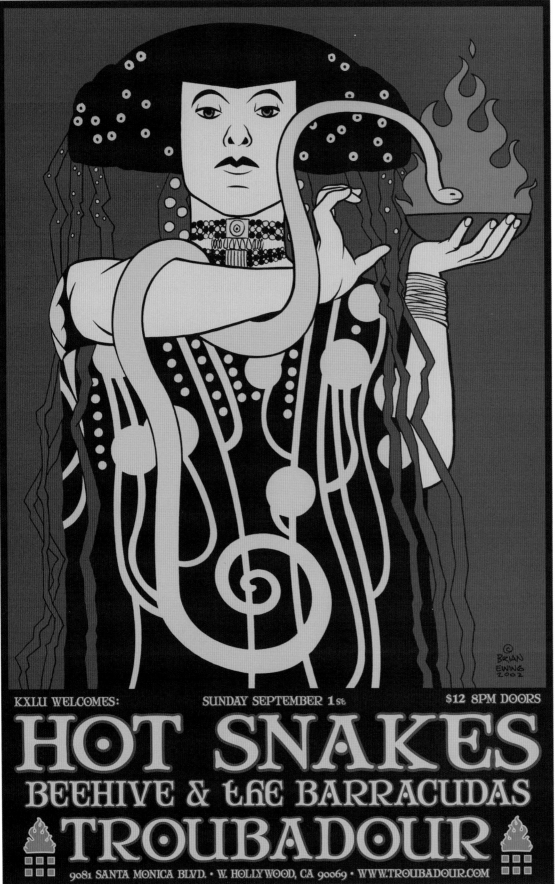

HOT SNAKES • BEEHIVE & THE BARRACUDAS
THE TROUBADOUR • HOLLYWOOD • 2002
11" x 17" OFFSET PRINT • EDITION OF 300

Two words: "John Reese." Long Gone John once said that "Reese has the map of Rock 'n' Roll tattooed on the back of his hand." At least I think he said that. Nonetheless, I always wanted to do a Rocket From The Crypt poster, but never had the chance. Believe you me, this was just as awesome!!!
I was letting the influence of Gustav Klimt and Jack Kirby tell me what to do. After the show I nervously went up to Reese and he remarked, "Hey, is this based off of Klimt?" That was rad!

"Back when Electric Frankenstein were a new band and we were happy that people like Kozik, Coop, Chantry, Forbes, and Ace were all making our posters, someone who was into Rock Art posters would always say, 'You need a Ewing.' What's a 'Ewing'? Well, I soon enough found out what a 'Ewing' was. And, yes, I NEEDED a 'Ewing,' more specifically I need an ELECTRIC FRANKENSTEIN poster designed by Brian Ewing.

"Why? Because Brian's artwork not only showed real skill and talent, but also had wry humor, its own cool iconography that traveled from poster to poster (who ARE these skeleton people, anyway!???), and it connected to the same subcultural contexts that Electric Frankenstein did in our music: Superheroes, Monsters, Girls, and Weirdness. Every 'Ewing' is a pleasure to see, always exciting and interesting and evocative. His posters take on a life of their own. When someone can surprise or perplex me, that says worlds about their Creativity and Imagination! Two words that best sum up a 'Ewing'!"

— Sal Canzonieri
Musician/ Author
Electric Frankenstein

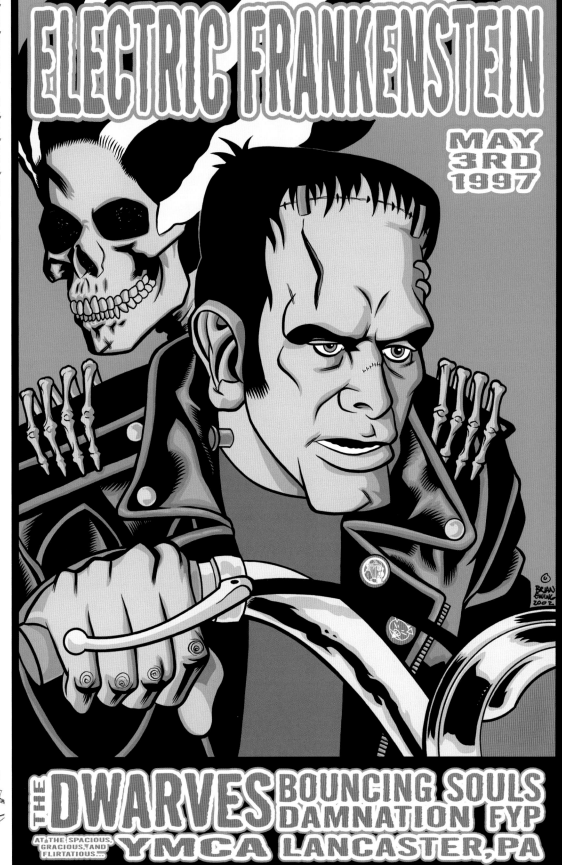

Sal Canzonieri (guitarist for Electric Frankenstein) asked a bunch of people to make posters for past E.F. shows. It was for his book *Electric Frankenstein!* published by Dark Horse Books. (Coincidence . . . hmm?) Part of the deal was that we weren't going to get paid, but . . . we could sell a limited edition of the poster. Finally a chance to draw Frankenstein!!!! Sal's a big supporter of illustration and rock posters, so it was an honor to be a part of the project. If you got $10 burning a hole in your pocket, pick up *The Time Is Now* by E.F. It's one of their best and one of the best albums of 2003! Don't forget the Dwarves — they will melt your brain and your heart.

ELECTRIC FRANKENSTEIN • THE DWARVES
BOUNCING SOULS • DAMNATION • FYP
YMCA • LANCASTER, PA • 1997
11" x 17" OFFSET PRINT • EDITION OF 300

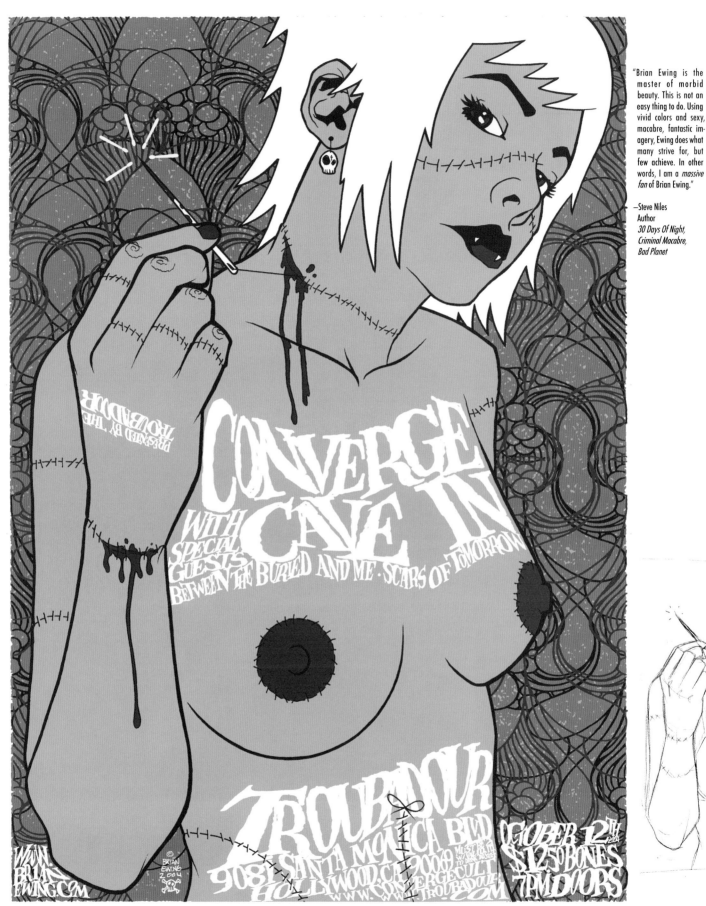

**CONVERGE • CAVE IN
BETWEEN THE BURIED AND ME
SCARS OF TOMORROW**

THE TROUBADOUR • HOLLYWOOD • 2004
18" x 24" FOUR-COLOR SCREEN PRINT • EDITION OF 300

This was originally for another band but it never got printed. I was trying out a new printer that wanted my biz but couldn't deliver. Someone there had a small problem with the subject matter and refused to print it. All the while, I'm in New York on the Warped Tour, and had no way of getting it to another printer. I didn't own a laptop, and it never occurred to me to bring a copy of the file with me. So, yeah . . . the work was done and it sat there. I was bummed, the venue was bummed, the band was bummed, and their label was bummed. Bummer. So here it is, new band and background, and it got printed. I'm happier with this version. I'm a huge fan of Jake Bannon and Converge, so I'm proud that it was used for a cool band.

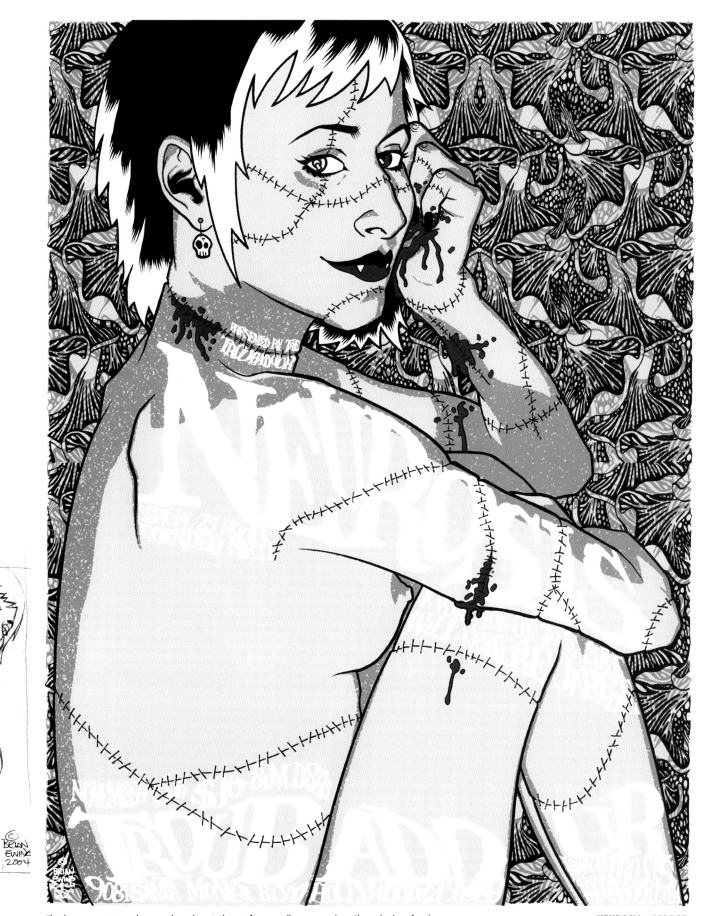

The show was amazing and over two hours long. Lucky you if you actually get to see them. They only play a few shows a year.

"Brian Ewing has a Graduate Degree in the Female Form, a Masters in Skulls, and a Ph. D. in balancing the beautiful and the gruesome."
—Print Mafia
Rock Poster Artists

NEUROSIS • JARBOE
THE TROUBADOUR • HOLLYWOOD • 2004
18" x 24" FOUR-COLOR SCREEN PRINT • EDITION OF 300

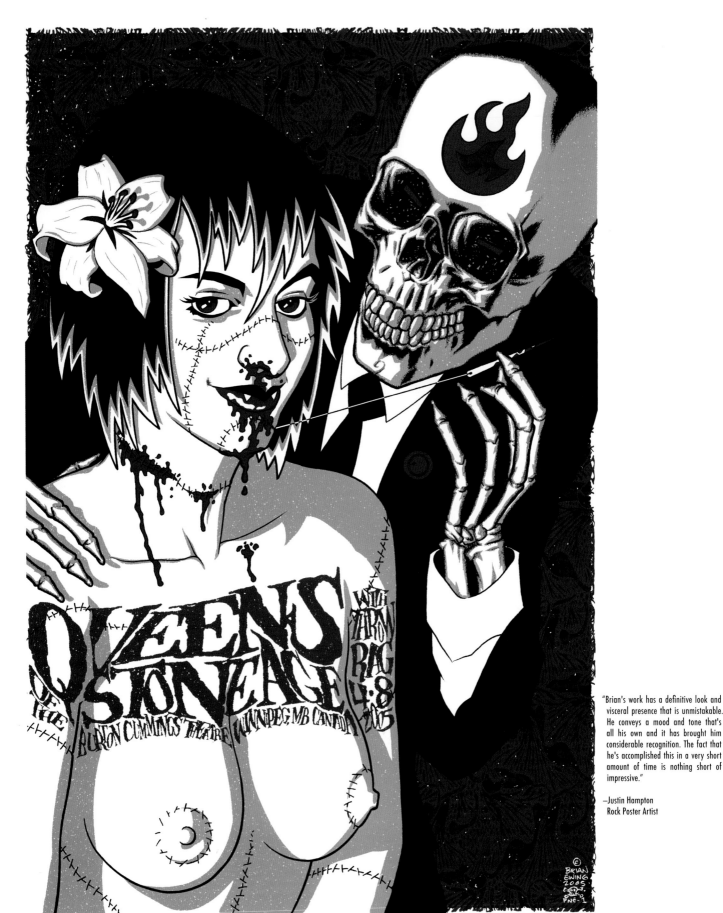

"Brian's work has a definitive look and visceral presence that is unmistakable. He conveys a mood and tone that's all his own and it has brought him considerable recognition. The fact that he's accomplished this in a very short amount of time is nothing short of impressive."

—Justin Hampton
Rock Poster Artist

QUEENS OF THE STONEAGE • THROWRAG
BURTON CUMMINGS THEATRE • WINNIPEG • 2005
18" x 24" THREE-COLOR SCREEN PRINT • EDITION OF 300

This was part of a series put together by the Post Neo Explosionism guys. I was one of many poster artists who were given the opportunity to contribute. I did my best to (professionally and in a friendly manner) knock the other artists down a peg with my poster. I had to! The other artists were much better and more established than I was.

Since the first days of Kyuss I've been a big fan of whatever Josh Homme was involved in. The first time I saw Qotsa was at 7th Street Entry in Minneapolis. Might have been able to fit one hundred people in there, and the place was packed. The first time I saw Kyuss was in Milwaukee, at the Eagle's Club. Must've been twenty people there. I'm either old or cool. Hard to tell.

"We met Brian when he was just another snot-nosed comic book/metal kid running around our record store. Soon enough, we struck up a sort of alliance with Brian and his like-minded cronies in the local band Ballpoint. Loved the band for all their heartfelt aspirations to Jesus Lizard and Slayer, but what really caught our attention was Brian's artwork. He was operating on a whole 'nother level than anyone else in town. His stuff was so clean and tight and imaginative and sinister, immediately recognizable as a 'Ewing.' It was simply a matter of time before he broke out of our little scene for the bright lights and mounds of crystal meth in Hollywood. To this day we still have a poster that Brian did in 1999 for a Ballpoint in-store hanging up above our seven-inch section; it's simply too badass to remove. Through the internets, we've been able to follow his path and watch in admiration as his renown and his talent grow. Tour busses, album covers, posters, T-shirts, the kid has become a one-man army. Just wish we would've bought more stuff from him before he left town; we'd probably make more money on that than selling records these days . . ."

—Bill Rouleau
Rushmor Records
Milwaukee

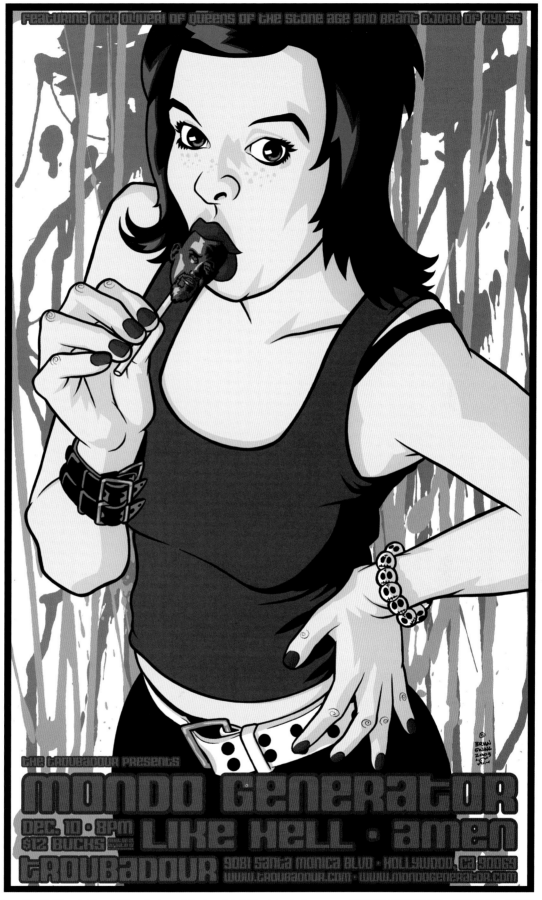

It was rad to see Mondo Generator. At the time it was Oliveri's side project (now full-time gig since splitting from Qotsa). Oliveri signed a few of these for me and started laughing. He didn't see the sucker at first, but when he did, it finally made sense. It's a *"Cherry Oliveri Pop."* Oy . . . I slay me.

MONDO GENERATOR • LIKE HELL • AMEN
THE TROUBADOUR • HOLLYWOOD • 2003
18" x 27" OFFSET PRINT • EDITION OF 300

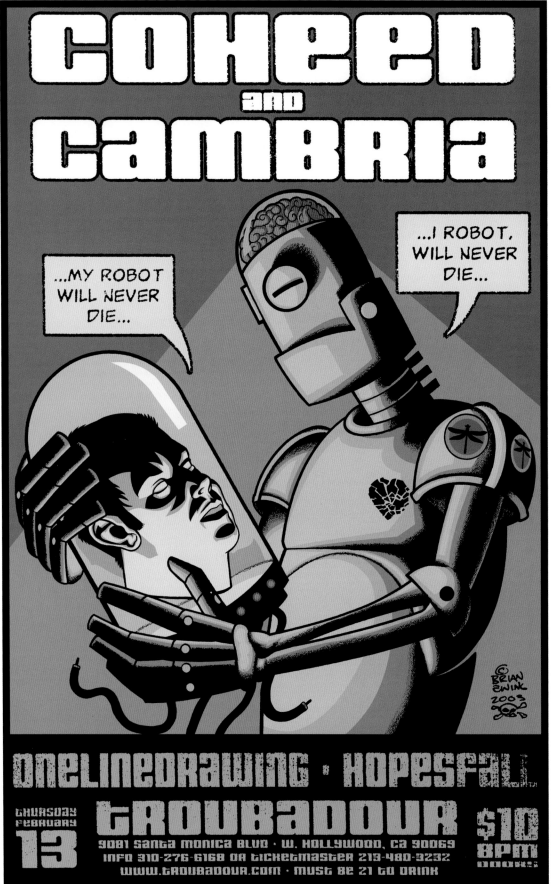

In 2004, *Guitar World* Magazine included a reprint of the poster in their December issue. Thanks to Josh Bernstein!

COHEED AND CAMBRIA
ONELINEDRAWING • HOPESFALL
THE TROUBADOUR • HOLLYWOOD • 2003
11" x 17" OFFSET PRINT • EDITION OF 300

My first poster for Coheed and Cambria. Their album *The Second Stage Turbine Blade* is still a favorite of mine. I'm really impressed with what Claudio Sanchez has done with his concept and how far he's taken it. Other bands have tried to do the same but have only failed.
This poster got bootlegged to high heaven. At one point a "respected" poster dealer had reprinted them without mine or the band's knowledge. He went so far as to forge my name. I found out from someone at SXSW when they gave me the poster and the tube it was shipped in. I confronted the dealer and he denied selling them. A few weeks later he died of a heart attack. Weird.

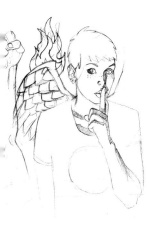

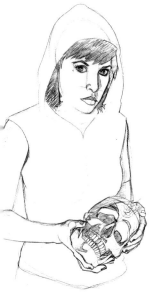

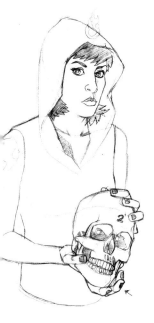

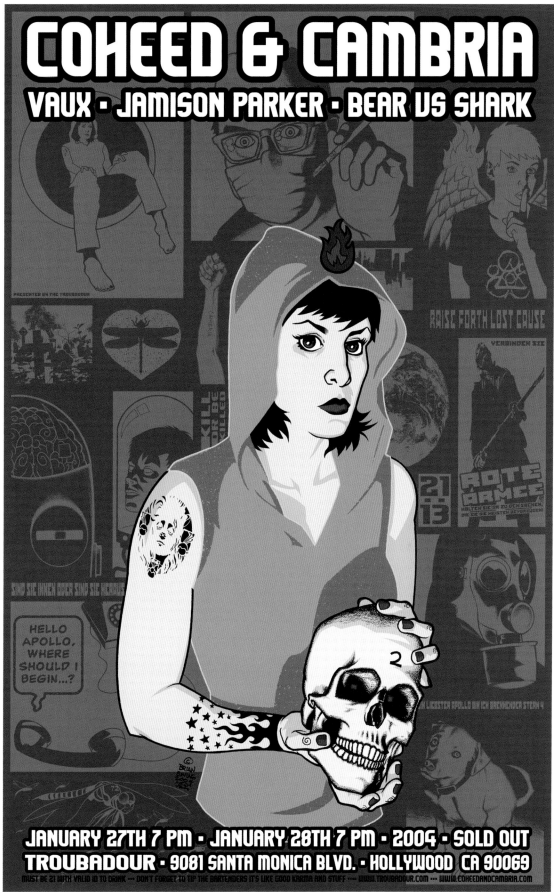

I busted my ass on this poster. I'm a big fan of the band and the storyline that runs throughout their albums and videos. Claudio Sanchez (the singer of Coheed & Cambria) published a comic-book series (*The Amory Wars*) to coincide with the albums. I did my best to make the poster relate to the storyline. At the time, the band didn't reveal too much of what was going on, and the comic book hadn't come out yet. I had no clue what the characters looked like. So I did my best to interpret their lyrics and the music videos while adding my own style. If you watch the C&C *Live At The Starland Ballroom* DVD you can see that they used this image on their tour laminates. That's my old roommate's dog Zoe in the corner there. Useless trivia.

COHEED & CAMBRIA • VAUX
JAMISON PARKER • BEAR VS. SHARK
THE TROUBADOUR • HOLLYWOOD • 2004
18" x 27" OFFSET PRINT • EDITION OF 300

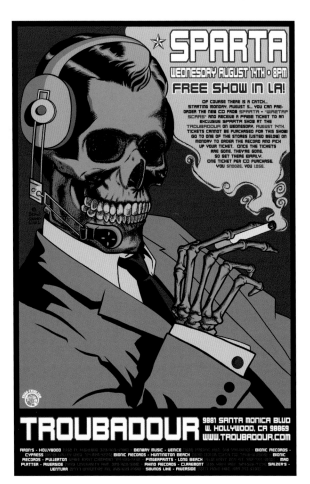

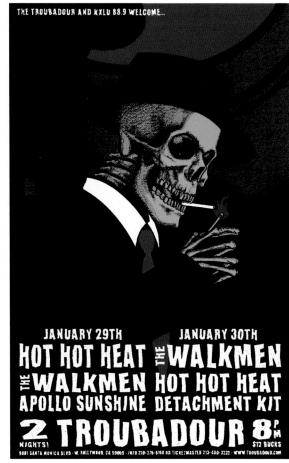

"When we first started working together in 2002–2003, Brian represented to me all things glamorous and sundry about the music industry. Here was a guy who got to do things like *know* and *be known by* musicians and music people without really having the responsibility attached to 'putting yourself out there as an artist.' He was the one who first illustrated to me (no pun) that commercial art was in some ways the best of both worlds: when something turns out good, it's of course your idea . . . When it's not so good, you got art directed to death by the client. Amazing, powerful logic. True and liberating in ways that really free one up to go forth, get laid, and make money.

"That is, until I started to get to know him. And I started to see just how painful it was for him to work on something that he didn't like, that he didn't believe in. Working with material that in some way is disagreeable to his own personal vision is, in fact, so stressful and awkward for Mr. Brian that he'll inexorably do the following things when such a situation arises:

"1. Fly headfirst and screaming into the project with every intention of turning it into a quick payday.
2. Realize after committing a full round of time and energy to his initial idea that he wants to take things in a different direction.
3. Stay up for no less than three days straight, shooting reference, sketching, baking ideas, and talking himself (and his client) into a more perfect version of the plan.
4. Persist in his awakened state throughout the production of the finished artwork that he will soon, but not just yet, come to realize that he is actually proud of.

"For, if there's anything that I've learned about Brian over the past five years, it's that he's no mercenary. His is a higher calling, and while going forth, getting laid, and making money is all well and good with him, he can't shake his sense of history. It's all very Vonnegut, but I can actually see Brian, sitting at his desk, getting ready to take a shortcut on a drawing in 2004. His hand outstretched, pencil at the ready, he stops himself, looks over at the camera, and says, 'But how will this look when it goes in my book?'"

—Justin Jewett
Rocket Society

Slayer were definitely the first band to scare the crap out of me when I was a kid. I remember going to my buddy Jason's house after school and he had just bought *Show No Mercy*. I hadn't even heard the music yet. It was the album cover that scared me. I was still in grade school and at that time we had a music class where we had to listen to audio shows by the Peters Brothers. Look them up. My ten-year-old brain was being reconditioned to fear Rock 'n' Roll and Heavy Metal. The Beatles, the Eagles, John Denver, Black Sabbath, Judas Priest, and so on. During their show they would backmask music and prove that Satan was warping my young mind to make me a teenage drop-out and serial killer.
It felt good to do this poster for Slayer. Thanks to that music class and the Peters Brothers for being such a huge influence on me.

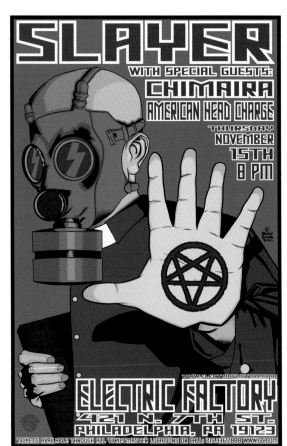

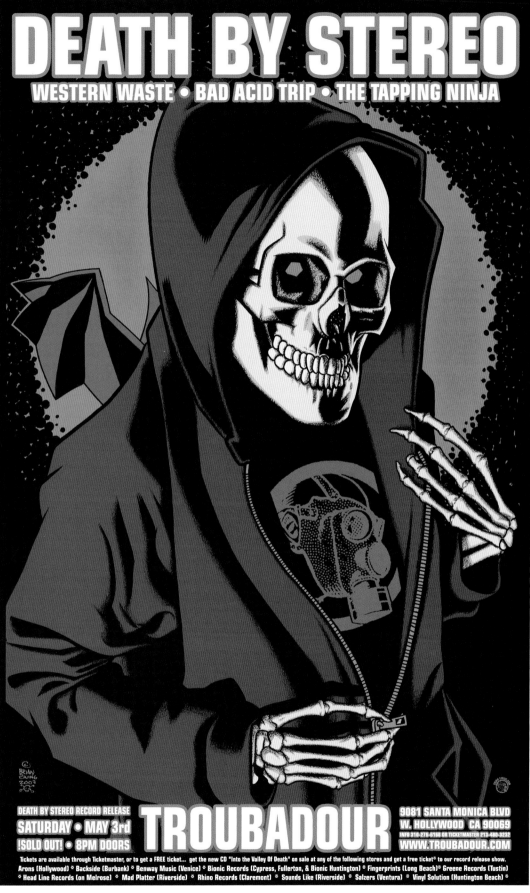

"I got to know Brian when I started with Atticus in early 2007. I was already aware of his work and so was excited when I heard we were working on a collaborative series with him. Since then, he has designed two incredible ranges of tees for us that have been favorites with Atticus fans, the bands we work with, and everyone at Atticus. In a pinch, my favorite would be his underwater tee, which has a ghostly figure looking up from under water. The great thing, in my humble opinion (I am not an art critic!), about Brian's work is its ability to blend various genres without leaning too heavily on one. It is often dark in mood without playing on every Gothic cliche, and still manages to be awesomely bright and eye catching. It owes a lot to comic art but contains an artistic depth beyond most comic art. Beyond his work, working with Brian has been awesome — he's a brilliantly driven artist with a wickedly dry sense of humor! It has been a pleasure."

—Andy Snape
Atticus Clothing

This was designed for Death By Stereo's record release show at the Troubadour. I was so tempted to draw Corey Haim from *The Lost Boys* for this, but I figured the joke would have gotten lost on people.

Atticus made a shirt based on this design for their fall '08 line. It was a collaborative line of signature shirts that I designed for them. One of the versions glowed in the dark! It was rad!

DEATH BY STEREO • WESTERN WASTE
BAD ACID TRIP• THE TAPPING NINJA
THE TROUBADOUR • HOLLYWOOD • 2003
11" x 17" OFFSET PRINT • EDITION OF 300

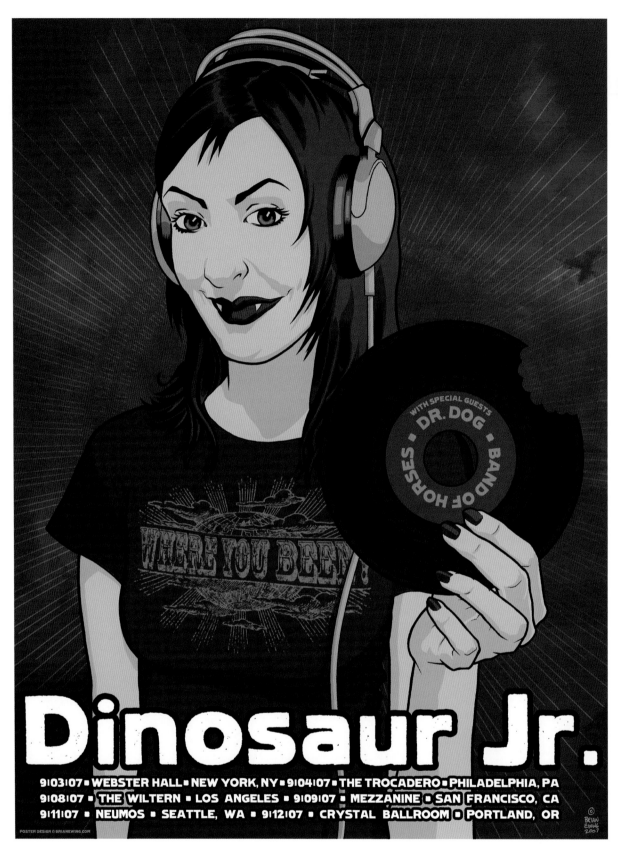

DINOSAUR JR.
TOUR POSTER
(VARIOUS CITIES) • 2008
18" x 24" OFFSET PRINT

Big project. Small deadline. I was commissioned to design a poster that could be changed seven different ways to help keep the costs down. I got to be a "color nerd" on this and go to town with different color combinations. The client made me sign a nondisclosure agreement, which basically meant I couldn't mention who sponsored the tour. Let's just say it starts with a C, ends with an L, and rhymes with *spamel*.

I experimented with creating my own backgrounds by using black ink on watercolor paper. Give it a shot. You can get some great abstract patterns.

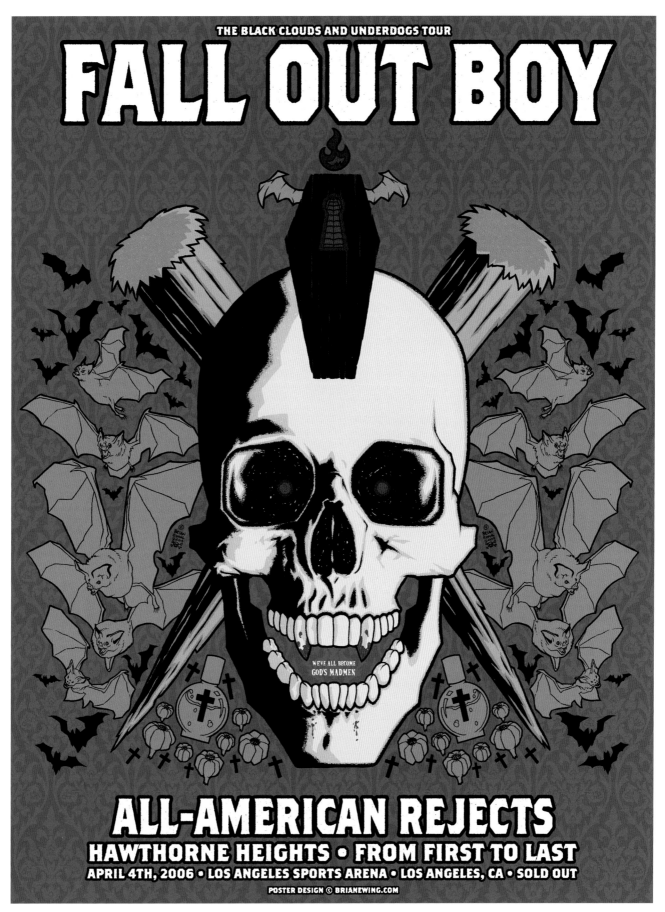

THE BLACK CLOUDS AND UNDERDOGS TOUR

FALL OUT BOY

WE'VE ALL BECOME
GOD'S MADMEN

ALL-AMERICAN REJECTS
HAWTHORNE HEIGHTS • FROM FIRST TO LAST
APRIL 4TH, 2006 • LOS ANGELES SPORTS ARENA • LOS ANGELES, CA • SOLD OUT

POSTER DESIGN © BRIANEWING.COM

This was commissioned by Cori Gadbury at Live Nation. She RULES!! I was trying my hand with mirroring some of my artwork. I drew one side of the bats and holy water then flipped it. I tried to draw both sides, but the likelihood of me being able to match them both up didn't seem that likely. It's based off of FOB's video for a song title I'm too lazy to type. The video was part *Buffy* and part *Thriller*. I liked the idea of them being vampire hunters. The video itself was no *Thriller*. But I liked the general concept.
The text inside the skull's mouth reads "We've All Become God's Madmen." It's a quote from Bram Stoker's *Dracula*. Pretty sneaky between the cheeky, huh?

FALL OUT BOY • ALL-AMERICAN REJECTS
HAWTHORNE HEIGHTS• FROM FIRST TO LAST
LA SPORTS ARENA • LOS ANGELES • 2004
18" x 24" OFFSET PRINT

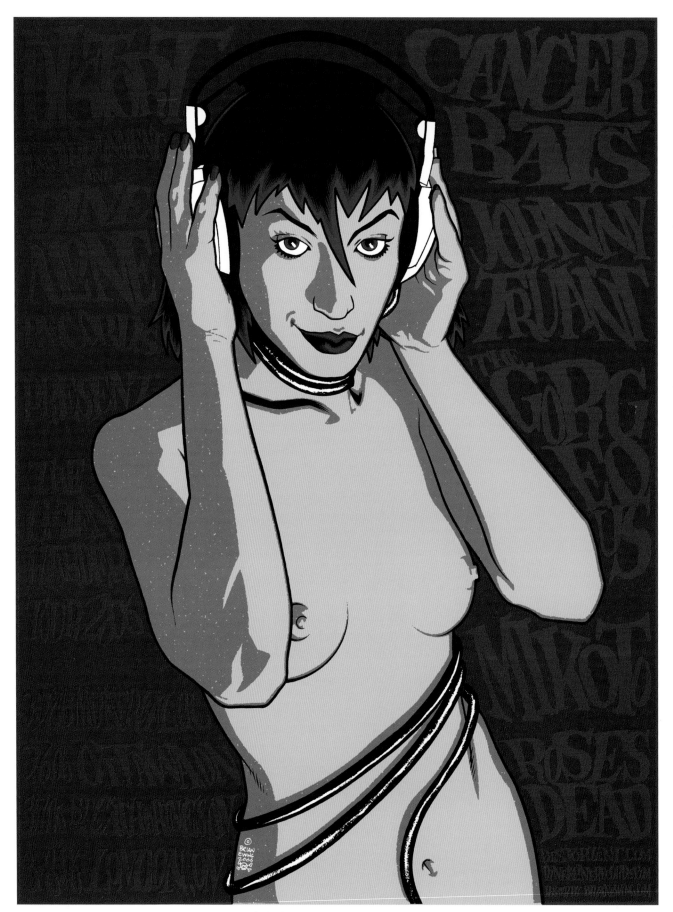

CANCER BATS • JOHNNY TRUANT
THE GORGEOUS • MIKOTO • ROSES DEAD
TOUR POSTER • CANADA • 2006
18" x 24" OFFSET PRINT • EDITION OF 300

Greg Below hired me to do this poster. We had emailed each other about working on a project but my schedule never fit with his. Then he finally introduced himself to me at SXSW. Greg is like . . . eight feet tall! He asked if I could do the poster for this tour and I was too scared to turn him down. He let me do whatever I wanted. It's funny cuz I think I sent him a version that was censored, expecting him to go with the safer one. Nope. Thanks, Greg!
I'm a sucker for girls wearing headphones.

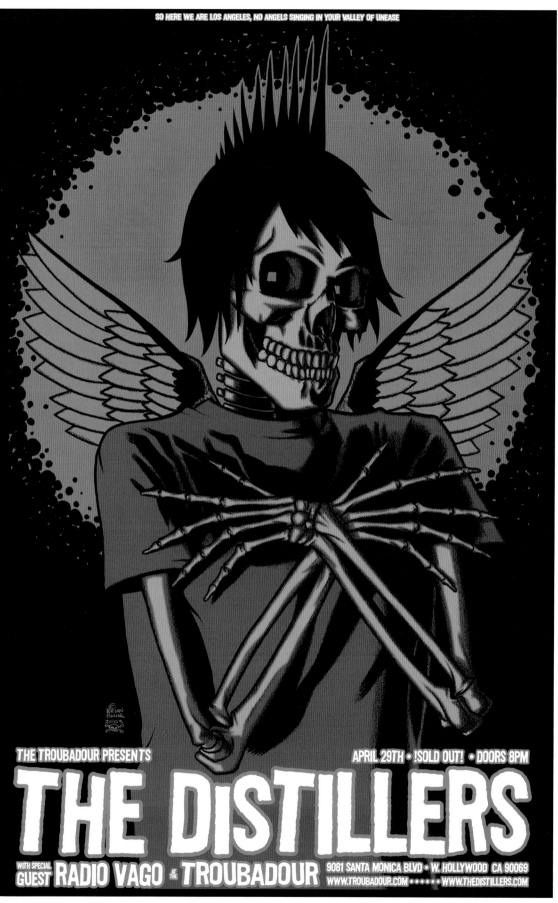

"Like Ralph Steadman and Big Daddy Roth bloodily colliding slap bang in the middle of a vicious maelstrom of broken canvases, drop-topped hot rods, paint smears, and smokin' punk rockin' babes, Brian Ewing ain't so much a breath of fresh air as a well-aimed kick to the balls of art snobs and hipsters the world over, making your favorite band even cooler and breaking your mama's heart."

—Jim Sharples
Editor, *Big Cheese* Magazine

THE DISTILLERS • RADIO VAGO
THE TROUBADOUR • HOLLYWOOD • 2003
18" x 24" 4-COLOR SCREEN PRINT • EDITION OF 175

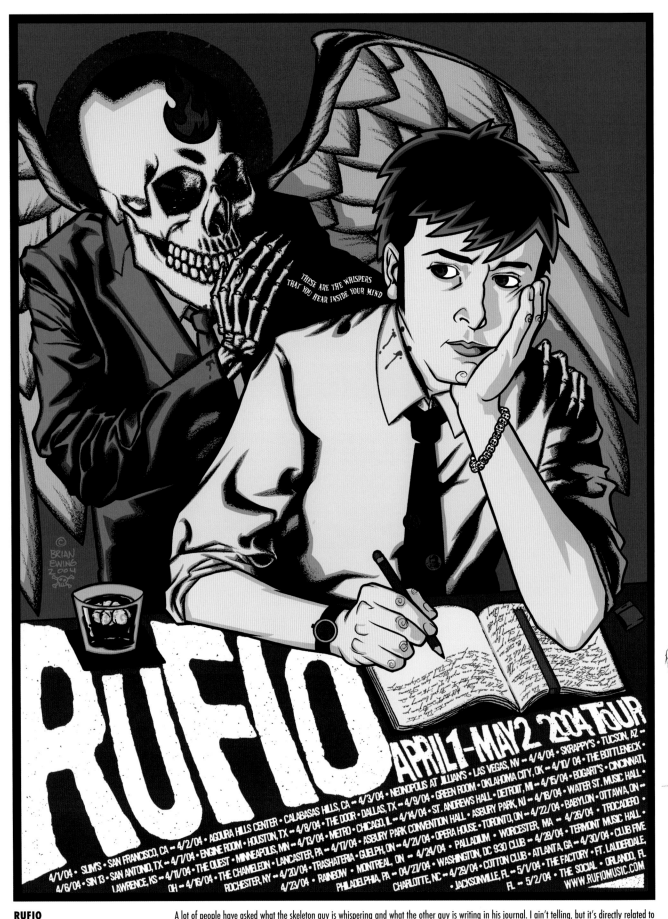

RUFIO
TOUR POSTER • 2004
18" x 24" OFFSET PRINT • EDITION OF 200

A lot of people have asked what the skeleton guy is whispering and what the other guy is writing in his journal. I ain't telling, but it's directly related to the music.
I had just seen Wim Wenders *Wings of Desire*. Check it out, Nick Cave is in it. I was heavily inspired by that movie for this poster and others.

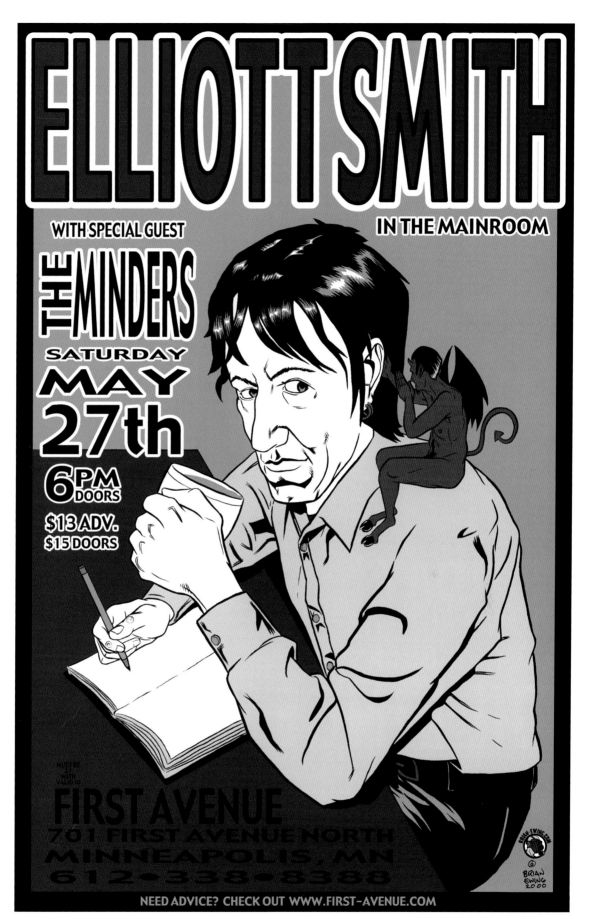

It was a sad day when I heard that Elliott Smith died. I used to see him often in Silverlake, at a tiny French restaurant that was a few blocks away from the wall that was used in the *Figure 8* album cover. After he died, the wall became a shrine to Smith. Covered in graffiti, poetry, and messages to him that he'll never get to read. It looks a lot like the graves of Jim Morrison and Oscar Wilde at Père Lachaise. I regret never introducing myself to him any of those times I saw him.

ELLIOTT SMITH • THE MINDERS
FIRST AVENUE • MINNEAPOLIS • 2006
11" X 17" OFFSET PRINT • EDITION OF 100

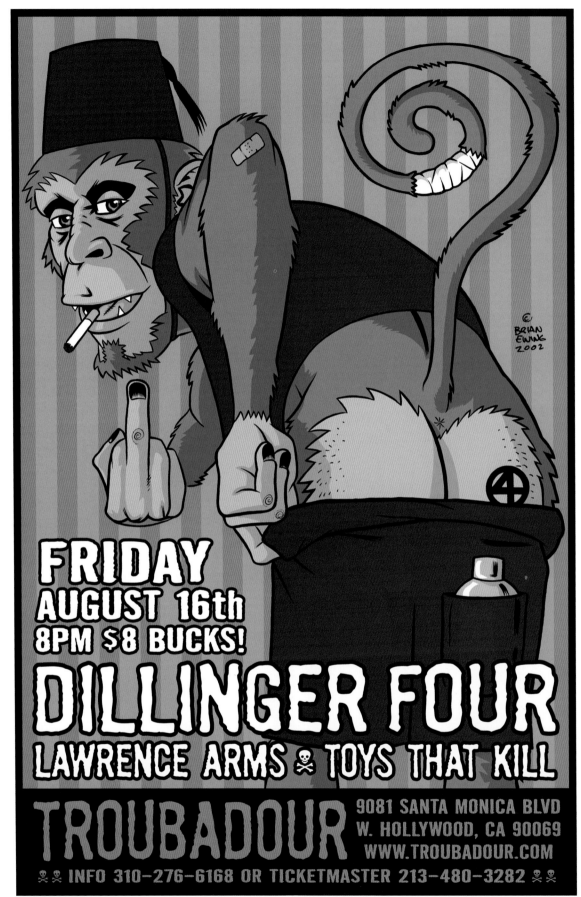

FRIDAY
AUGUST 16th
8PM $8 BUCKS!
DILLINGER FOUR
LAWRENCE ARMS ☠ TOYS THAT KILL
TROUBADOUR
9081 SANTA MONICA BLVD
W. HOLLYWOOD, CA 90069
WWW.TROUBADOUR.COM
☠☠ INFO 310-276-6168 OR TICKETMASTER 213-480-3282 ☠☠

DILLINGER FOUR
LAWRENCE ARMS • TOYS THAT KILL
THE TROUBADOUR • HOLLYWOOD • 2002
11" x 17" OFFSET PRINT • EDITION OF 300

Dillinger Four are a band that defined Minneapolis, for me when I lived there. I would see them play all the time. This show was awesome! Yes . . . they *killed it* and Paddy was naked. After the show, I met up with the band and I got to reminisce about Minneapolis for a while. A year later I caught them at Emo's during SXSW. Way too much fun. After they were done playing I walked towards the band to reintroduce myself when all of the sudden a half-naked and sweaty Paddy Costello grabbed me and swung me around the room. I think I took out a person or two with my feet. Buy *Situationist Comedy* if you want to hear one of the best bands to ever come out of Minneapolis! Blue Starfish.

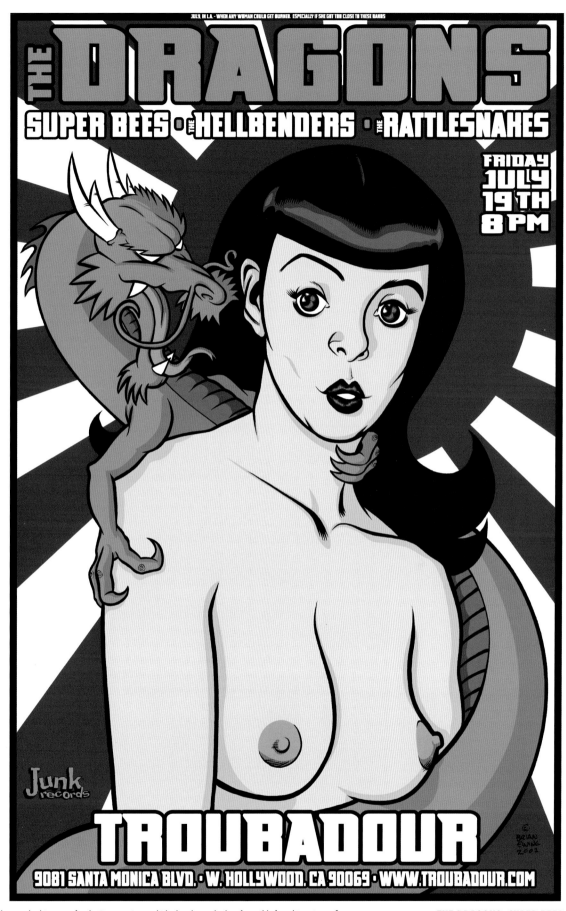

Lou Carus, owner of Junk Records, hired me to do this poster for the Dragons. Lou and I had exchanged a lot of email before this trying to figure out what I could do. I met him prior when I invited him to set up a table at a skate shop where I was in a group show with Dan St. George and Mike Orduna (Fatoe). Sounds strange . . . it was. Keith Morris showed up, too.

Anyways . . . Lou invited me and my girlfriend to hang out with him at Jumbo's Clown Lounge a few blocks away. We were getting pretty sauced sitting up front by the stage when he said, "Hey, I think I got a hand job from that chick once!" I looked and could swear I saw a five o'clock shadow and Adam's apple. "Are you sure?" I asked. "Cuz I think that's a dude!"

THE DRAGONS• SUPER BEES
THE HELLBENDERS • THE RATTLESNAKES
THE TROUBADOUR • HOLLYWOOD • 2002
11" x 17" OFFSET PRINT • EDITION OF 300

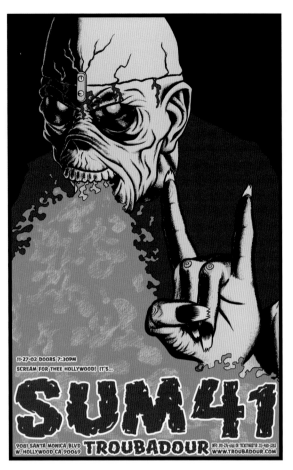

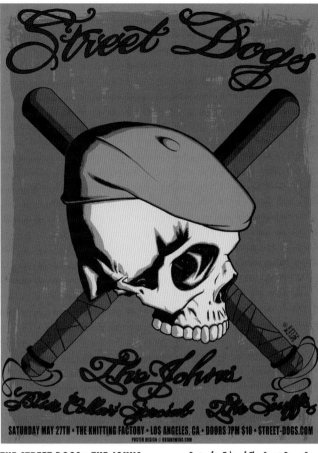

SUM 41

THE TROUBADOUR • HOLLYWOOD • 2003
11" x 17" OFFSET PRINT • EDITION OF 300

This pissed off every Iron Maiden fan on the planet. Haha . . . whoops. Sum 41 are huge fans of Maiden, so I thought it would be fun to make a poster that's more metal than what you normally see done for the band.

This was the first time I had drawn Eddie since high school. All I ever wanted to do in high school was see a girl's boobs and draw like Derek Riggs. Neither happened until much later.

Hey, Iron Maiden . . . hire me to do a poster!!!! Matt Ash, hook it up!!

THE STREET DOGS • THE JOHNS
BLUECOLLAR SPECIAL • THE SCUFFS

THE KNITTING FACTORY • HOLLYWOOD • 2006
11" x 17" OFFSET PRINT

Poster for Tobe of The Street Dogs. Great great great band. I just made enough for the band and never sold copies off my site. So don't email me about it.

Tried to experiment with hand-lettering. My buddy Josh lent me some tattoo lettering guides to work from for this poster.

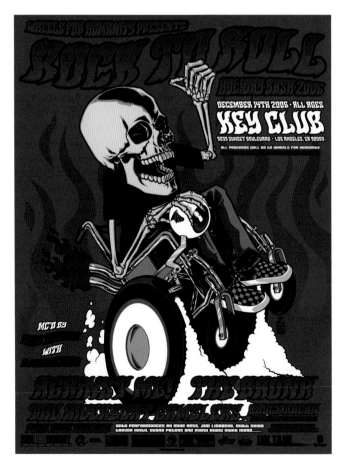

"I met Brian for the first time when I interviewed him for Complete Control Radio on Indie 103.1 in LA. I remember we called his mother live on the air that night. I asked her if her son's artwork scared her. I think she said, 'It worries me sometimes.' Brian Ewing's art is unique and completely independent from what anyone else is doing. His artwork has established 'Rock To Roll' as a special event in giving people the gift of mobility. Please visit ucpwheelsforhumanity.org and make a donation."

—Joe Sib
Sideone Dummy Records
Complete Control Radio

ROCK TO ROLL BENEFIT #1
AGAINST ME! • THE BRONX
THE RIVERBOAT GAMBLERS
CHUCK RAGAN

KEY CLUB • HOLLYWOOD • 2006
18" x 24" OFFSET PRINT

Designed this for Ashley Dechter and Joe Sib over at Sideone Dummy Records. Joe put together a benefit show and got some really great bands and performers to volunteer their time for Wheels For Humanity. WFH is a charity that refurbishes old wheelchairs and gives them to people who need them the most. I'm sure they do more than that, so go and check out their website. When I got the call from Joe to donate my time to design a poster, I couldn't say no. How can you? Joe is one of the coolest guys I've met working in the music industry. If you haven't caught Joe's radio show *Complete Control Radio* you should check it out. It's on the internets.

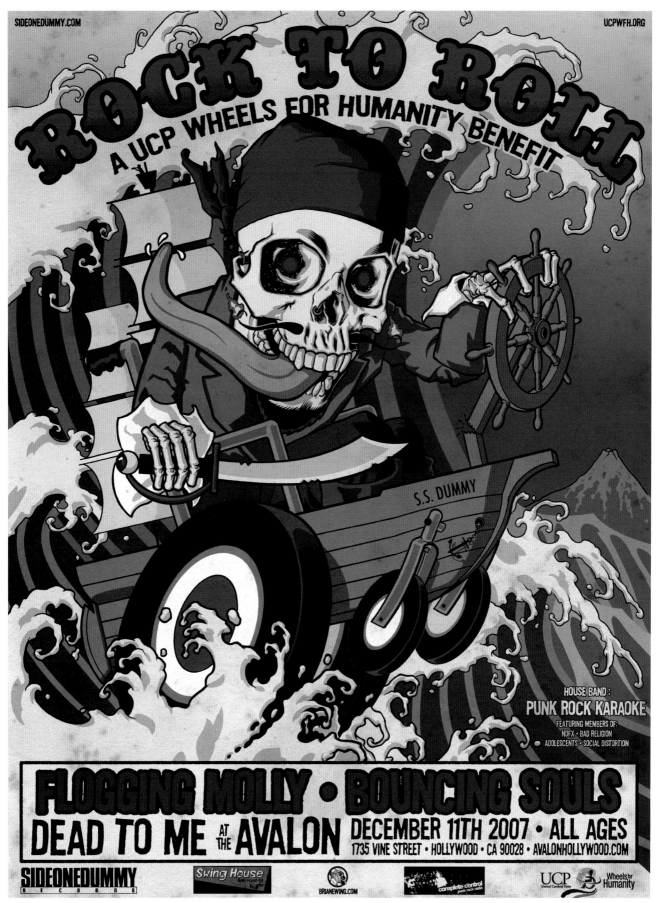

ROCK TO ROLL

A UCP WHEELS FOR HUMANITY BENEFIT

S.S. DUMMY

HOUSE BAND :
PUNK ROCK KARAOKE
FEATURING MEMBERS OF:
NOFX • BAD RELIGION
ADOLESCENTS • SOCIAL DISTORTION

FLOGGING MOLLY • BOUNCING SOULS
DEAD TO ME AT THE AVALON
DECEMBER 11TH 2007 • ALL AGES
1735 VINE STREET • HOLLYWOOD • CA 90028 • AVALONHOLLYWOOD.COM

SIDEONEDUMMY
RECORDS

Swing House

BRIANEWING.COM

complete control
punk rock radio

UCP
United Cerebral Palsy

Wheels for
Humanity

This is the second year I've designed the poster for the Rock To Roll bash. I tried a few different things on this that I haven't really explored before. I think I did a better job than my poster for last year's event. Joe wanted to continue with the "skeleton kid" and Ed Roth style but add a pirate theme as well. This was also made into a 12' x 12' backdrop and a T-shirt. Where's my shirt, Joe?

Check my website. I wrote a tutorial detailing how I drew and inked this piece.

ROCK TO ROLL BENEFIT #2
FLOGGING MOLLY
BOUNCING SOULS • DEAD TO ME
THE AVALON • HOLLYWOOD • 2007
18" x 24" OFFSET PRINT

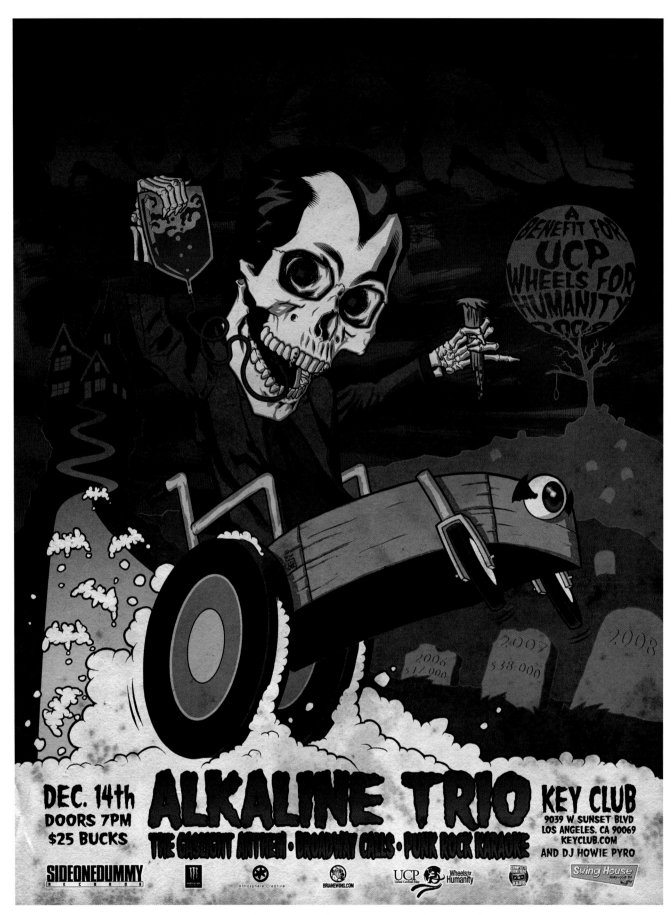

ROCK TO ROLL BENEFIT #3
ALKALINE TRIO • THE GASLIGHT ANTHEM
BROADWAY CALLS • PUNK ROCK KARAOKE

THE KEY CLUB • HOLLYWOOD • 2008
18" x 24" OFFSET PRINT

Third time's a charm. I've been wanting to do a poster for Alkaline Trio for so long! Joe wanted to continue with the "skeleton kid" and Ed Roth style again. I had a lot of fun doing this because I got to take my love for old horror comics, Universal Monsters, and Rat Fink. I wish every job was this much fun.
I went to LA to check out the show, and as I was walking toward the venue I could see the artwork on the marquee for all of Sunset Strip to see. This was also made into a 12' x 12' backdrop and a T-shirt.

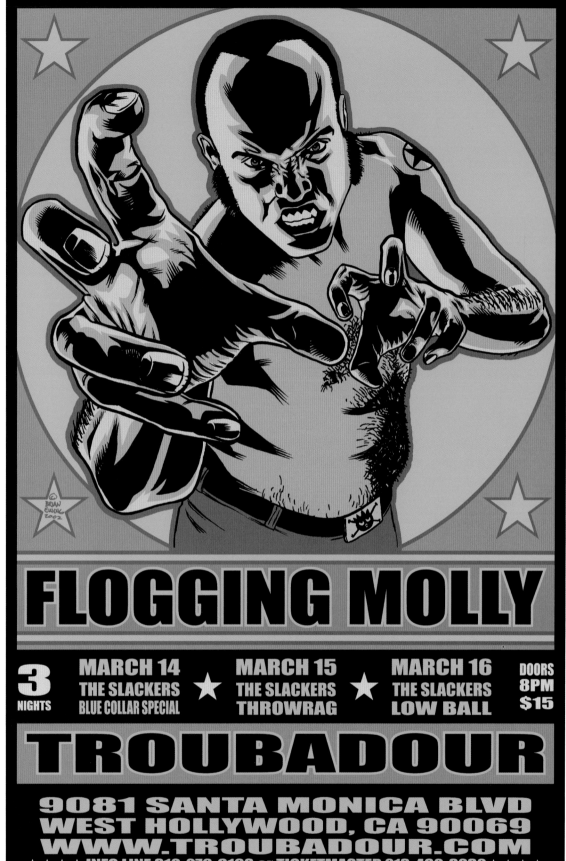

Dear Brian — Thank
you for the poster(s),
it's terrific, and I
plan to have it
framed next week
Enclosed are a
couple FM CDs
I hope that they
will inspire! Be
in touch soon as
they are now work-
ing on the new album
and will turn it in
mid-March (June release)
can put you in touch
with them direct if
you have any ideas
Thanks again Della

That's my old studio mate from Minneapolis, Shad Petosky. He's now running a very successful agency called PUNY. Anyway, Shad posed for this poster. That's the meanest you will ever see this guy get. To the left is a letter from Ella Schmidt (wife of Bob Schmidt), who plays mandolin and banjo in Flogging Molly. She found my website after seeing the poster. One of the dates of the show was also the Schmidt's wedding anniversary. She sent me a nice email asking to purchase some copies so she could frame one and give it to her husband as a gift. Now I couldn't just sell her the poster. My biggest fault is that I'm not greedy enough to survive the music biz. I sent her a bunch of posters and in return she sent me a letter with some of the band's CDs. Way better than cash!

FLOGGING MOLLY
THE SLACKERS • THROWRAG
BLUE COLLAR SPECIAL • LOWBALL
THE TROUBADOUR • HOLLYWOOD • 2002
11" x 17" OFFSET PRINT • EDITION OF 300

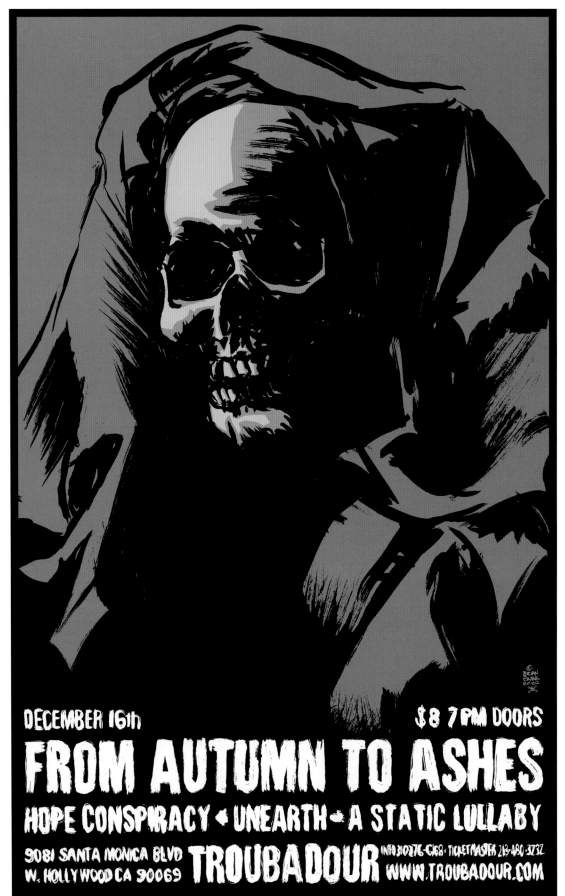

FROM AUTUMN TO ASHES
HOPE CONSPIRACY •UNEARTH
A STATIC LULLABY
THE TROUBADOUR • HOLLYWOOD • 2002
11" x 17" OFFSET PRINT • EDITION OF 300

I pulled this one out of my sketchbook. I was goofing around with trying to be more "painterly" with my inking. Heavily inspired by the art of John J. Muth and Clive Barker. I threw my work shirt over a skull and lit it with a desk lamp. It was just a still life until someone suggested I use it for a poster. I did the text by hand with a shitty brush. Some people thought it was a font, and that's fine by me, cuz it was a pain in the ass to make it look like one.
I traded Kozik the original art for one of his drawings. Score!

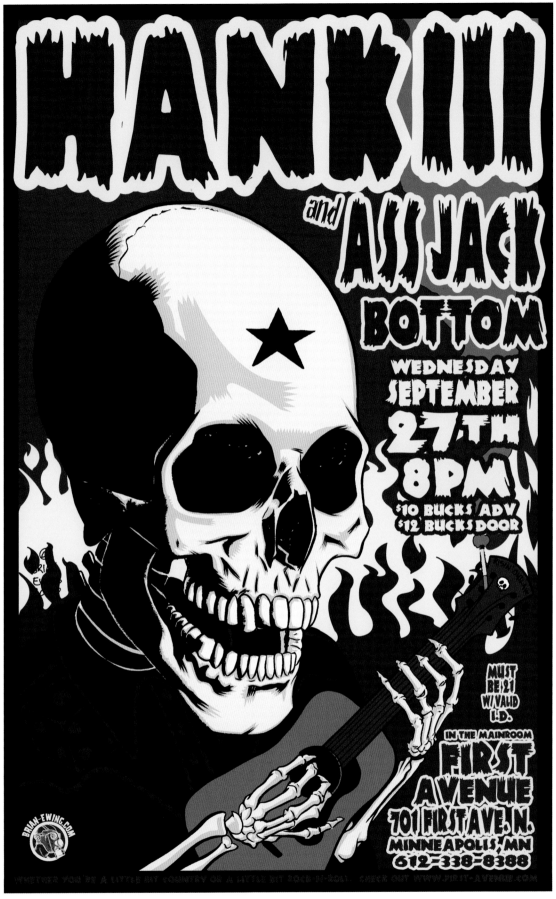

Assjack is Hank III's Metal band. He and his band would do two sets. The first was usually the Country set. Then after an intermission they'd come out again to play their Metal set. I received an email from a Southern lady in her seventies. She was a big fan of the Williams legacy and was upset that I drew a skull for Hank III. Really nice lady. I explained my reason and the direction that Hank III was going with his music. After that we became instant friends and exchanged emails for a few years.

This poster got me a job doing illustrations for everyone's favorite porno mag, *Barely Legal*. I showed it to Mackie, the art director, and next thing I know I'm drawing naked young (and legal) girls in precarious situations. Wait . . . I think I need a minute to reflect.

HANK III • ASSJACK • BOTTOM
FIRST AVENUE • MINNEAPOLIS • 2004
11" x 17" OFFSET PRINT • EDITION OF 300

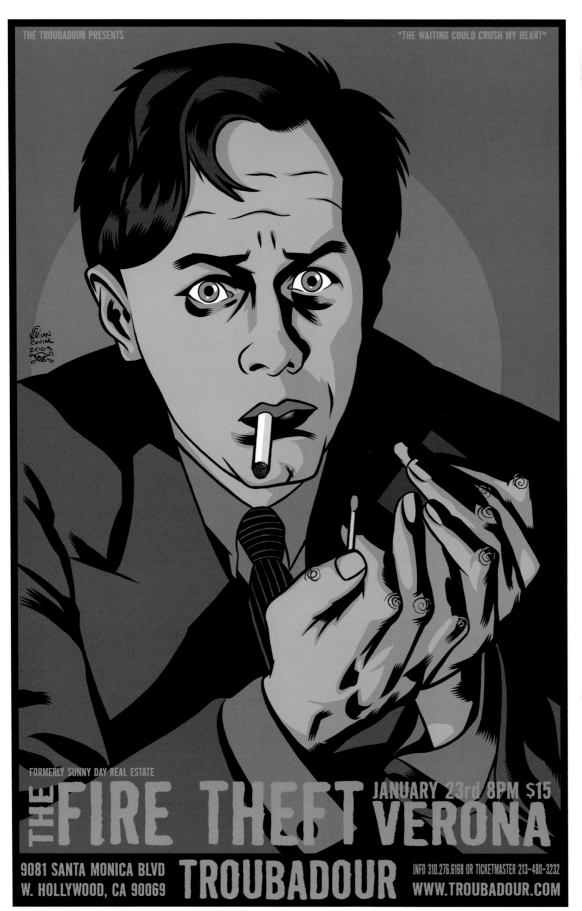

THE FIRE THEFT • VERONA
THE TROUBADOUR • HOLLYWOOD • 2003
11" x 17" OFFSET PRINT • EDITION OF 300

Sunny Day Real Estate were the be-all-end-all band for a lot of people I know when I lived in Minneapolis. My buddy Jason Knudson handed me a copy of their album *Diary,* and I never turned back.

After this show, one of the guys in the band asked me why I drew this picture. I told him that "I thought the music was far from happy and sorta desperate." I meant it as a compliment. This was heavily inspired from the movie *Night and the City.* Probably one of the best film noir movies. Right up there with *The Third Man.*

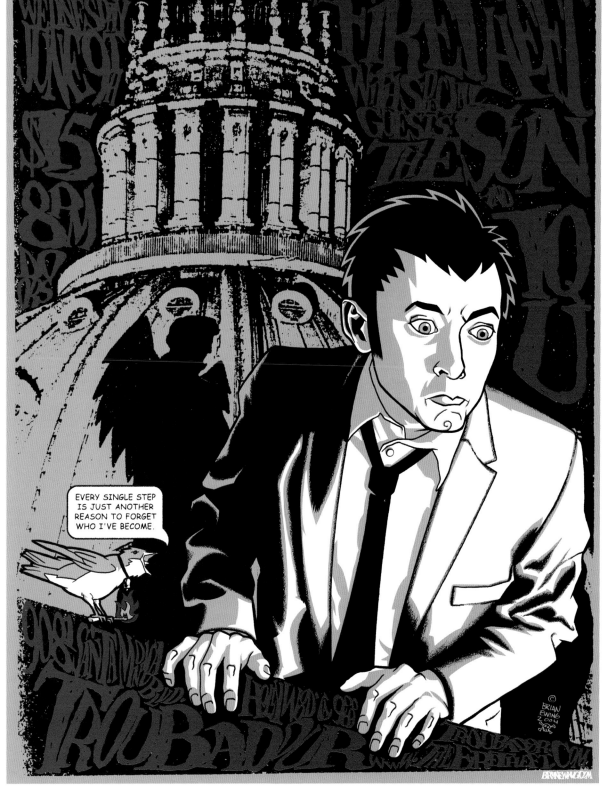

"What can you say about Brian Ewing? When you first think of Brian you might think of skulls, and no-body does them better, but there is so much more to the work than that. The execution and design put Brian in the top tier of designers. He's a designer with a style all his own, crafting eye-catching and powerful creations on prints, posters, and basically anything he touches. He is truly deserving of his place in the galleries of the world, as an artist who happens to work for some great bands doing great things. So much more than just posters and skulls."

–Richard Goodall
richardgoodallgallery.com

The building in the background is from a photo I took of St. Peters in Rome. I got a chance to visit a few years ago when a girlfriend was stationed there, excavating in the Roman Forum. I started my day with getting a private tour of the catacombs beneath St. Peters and ended it with going to the top. Or as far as they'd let us go. I never really thought about my fear of heights until I went to the top.
I had a print made of the photo and I xeroxed it to get the effect I wanted. Then I put it behind the drawing of the guy contemplating if he should jump or not. The bird wasn't helping.
I grew up on a steady diet of Sunny Day Real Estate. That band just put out great music. The Fire Theft had a lot of pressure on them to do the same.

THE FIRE THEFT • THE SUN • IQU
THE TROUBADOUR • HOLLYWOOD • 2004
18" x 24" THREE-COLOR SCREEN PRINT
EDITION OF 300

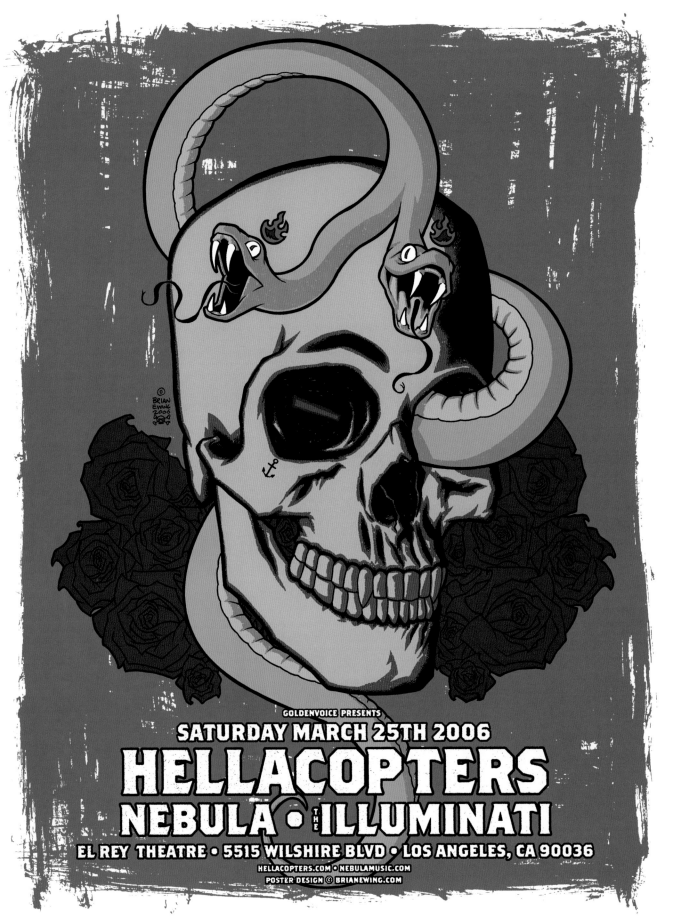

GOLDENVOICE PRESENTS
SATURDAY MARCH 25TH 2006
HELLACOPTERS
NEBULA · THE ILLUMINATI
EL REY THEATRE · 5515 WILSHIRE BLVD · LOS ANGELES, CA 90036
HELLACOPTERS.COM · NEBULAMUSIC.COM
POSTER DESIGN © BRIANEWING.COM

HELLACOPTERS
NEBULA
THE ILLUMINATI
EL REY THEATRE · HOLLYWOOD · 2006
18" x 24" OFFSET PRINT · EDITION OF 300

Some people claim to *Respect The Rock* but never bothered to check out the Hellacopters. An amazing band. Same with Nebula, which had spawned from Fu Manchu. I tried something different for this. Yeah, I know it's a skull. Hanging out with my buddies Sarah and Josh Stanton has had an underlying influence on me. We talk about tattoo art, Metal, and some of my parasitic ex-girlfriends. Oh, the stories . . .

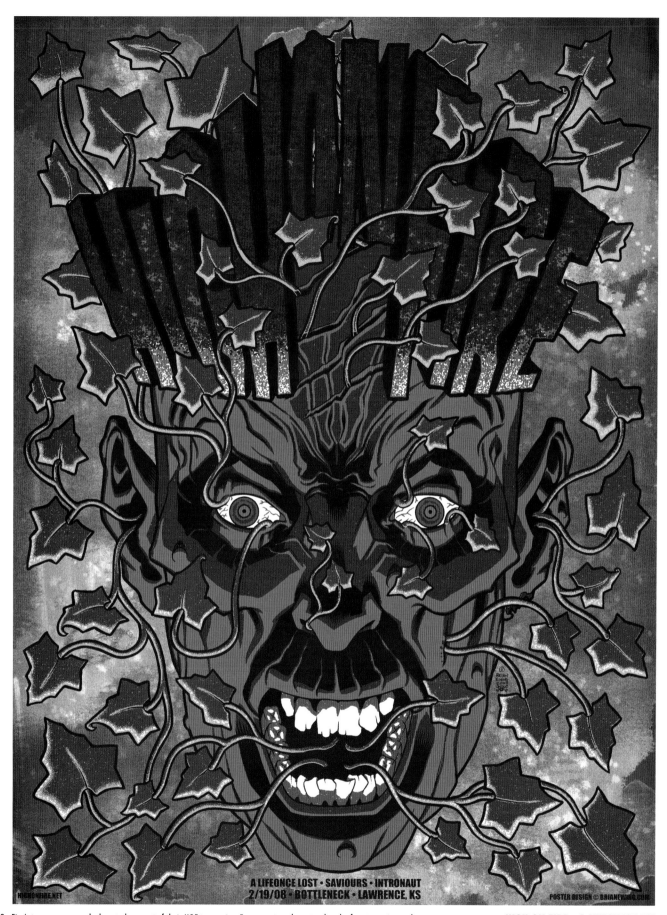

A LIFEONCE LOST • SAVIOURS • INTRONAUT
2/19/08 • BOTTLENECK • LAWRENCE, KS

HIGHONFIRE.NET

POSTER DESIGN © BRIANEWING.COM

Moss, High On Fire's tour manager, asked me to be a part of their HOF tour series. For every tour, he gets a bunch of poster artists to do a poster for one of the tour dates. Nice way to start 2008.
I tried experimenting with over-printing and diffusion dither. Something I learned from my buddy Dan St. George. Having fun with the orange and green theme of the amp manufacturer Orange. They made special heads for HOF called Green. Useless trivia.

HIGH ON FIRE • A LIFEONCE LOST
SAVIOURS • INTRONAUT
THE BOTTLENECK • LAWRENCE, KS • 2008
18" x 24" FOUR-COLOR SCREEN PRINT • EDITION OF 250

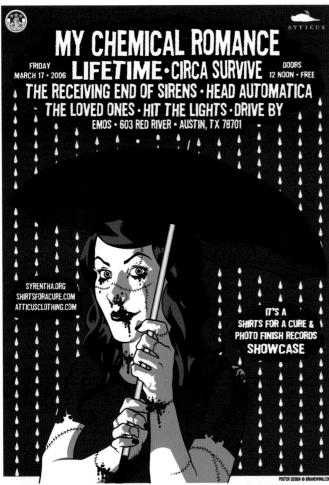

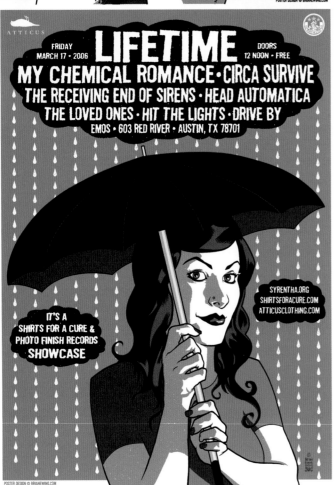

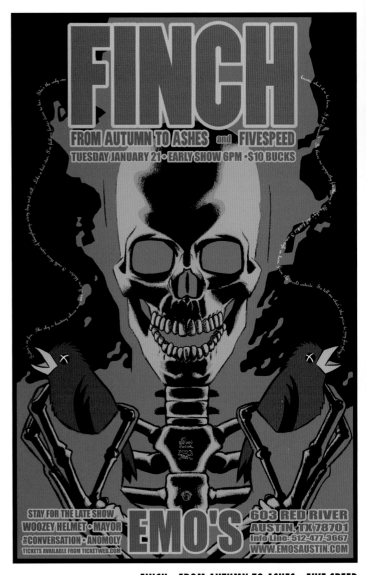

FINCH • FROM AUTUMN TO ASHES • FIVE SPEED
EMO'S • AUSTIN • 2003
11" x 17" OFFSET PRINT • EDITION OF 300

Finch is another one of my favorite bands. *What It Is To Burn* was a great album. The lyrics coming out of the birds mouths are from the title track. In 2008, these guys were cool enough to play an exhibition that Atticus Clothing had put together for me so they could debut their new shirts I designed. Paige Hamilton (from Helmet) joined them on stage to belt out a few Helmet covers as well. Holy shit, I was floored. Billy Corgan was spotted in the crowd as well. Afterwards we all went to the Rainbow Bar & Grill and closed the place. I'm still hung over from that night.

MY CHEMICAL ROMANCE
LIFETIME • CIRCA SURVIVE
EMOS • AUSTIN • 2006
13" x 19" OFFSET PRINT • EDITION OF 300

Atticus asked me to do something for their SXSW showcase and wanted two posters for the same event. I was gonna cheese it out and do one piece and just change the text . . . which I kinda did. I ended up drawing both pieces instead of Photoshopping the blood and scars in. I did the job for free. It's to benefit cancer research for women. Shirtsforacure.com

"Working with Brian over the years has been amazing. Easily one of the most talented, humble, and hard-working artists of our time. I remember that when we first met him we had to go to his house to shoot pictures of him 'working' for the Atticus catalog, we felt so awkward trying to make everything 'natural,' but he was a sport about it and made us feel right at home. Eventually we commissioned Brian to do a set of posters for a Shirts For A Cure benefit featuring Lifetime and My Chemical Romance at SXSW. They are some of my favorite pieces he's done."

—Brendan Klein
Loserkids.com

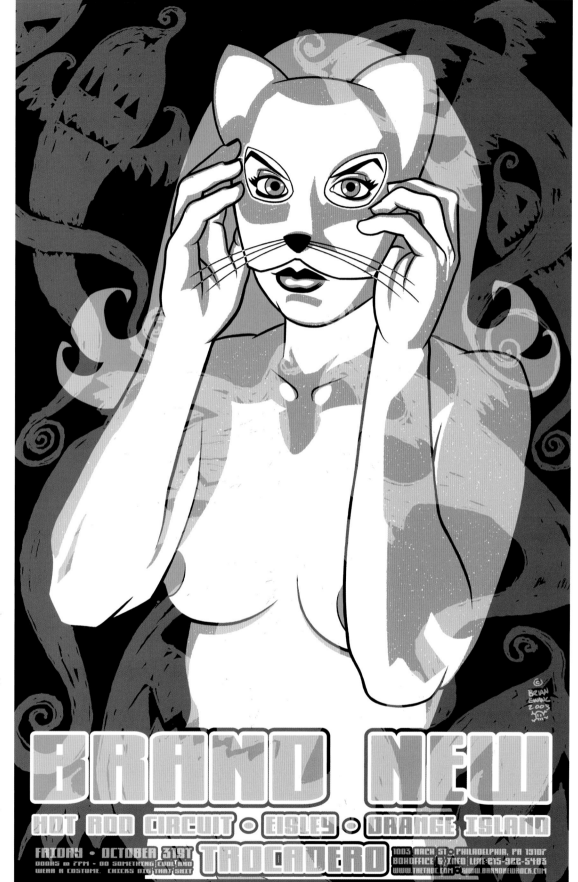

I designed this for Brand New after the tour poster, but this came out first. I've had the opportunity to do posters for Halloween shows before but never felt like I did a good job. I think I finally got it right with this one. I wanted to draw a cute girl. The band didn't complain. Their music is about relationships, after all. One of their fans found this offensive. Boobs are offensive. Now I'm going to cut that into my wrist and write a poem about it. Sheesh . . . get a fucking life!
The idea to overprint the ghosts was inspired by looking at a lot of Jordan Crane's work. Great artist and funny guy. He likes boobs.

BRAND NEW • HOT ROD CIRCUIT
EISLEY • ORANGE ISLAND
TROCADERO • PHILADELPHIA • 2003
18" x 24" SCREEN PRINT • EDITION OF 300

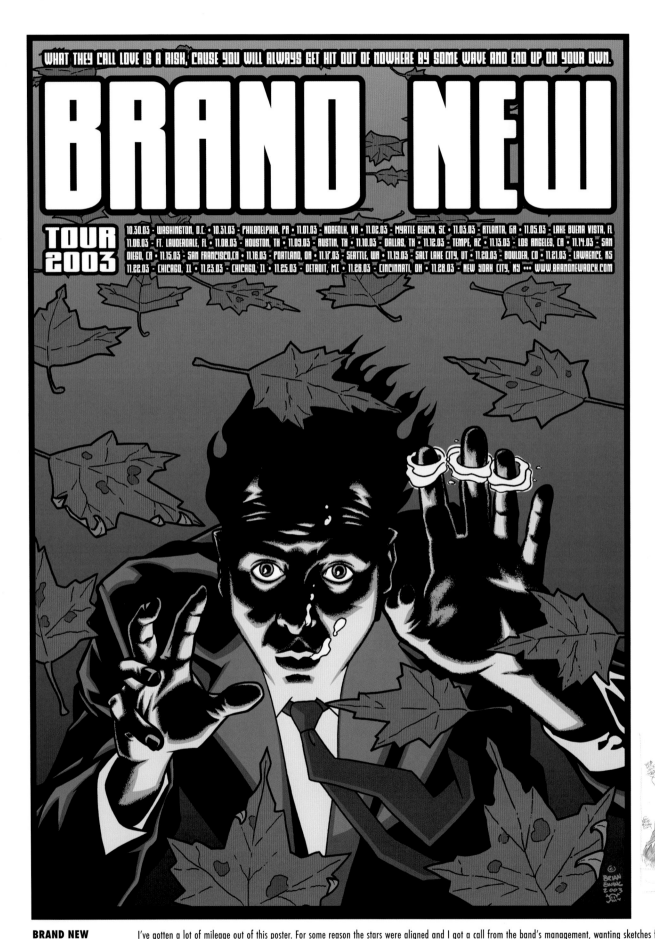

BRAND NEW
US TOUR POSTER • 2003
18" x 24" OFFSET PRINT
EDITION OF 300

I've gotten a lot of mileage out of this poster. For some reason the stars were aligned and I got a call from the band's management, wanting sketches for a tour poster and backdrop. I turned in a bunch of sketches illustrating various songs. No good. They weren't iconic enough. I had this piece, finished and sitting around from a previous project, where the band promised to pay me and never did. I sent this to Brand New and that was that. A few months later, the band was playing at the House of Blues in Los Angeles, and they invited me to show. I get there and what's the first thing I see? This piece enlarged to twenty feet high — staring right at me. I stood there for a few minutes with a shit-eating grin, thinking that I finally made the next step.

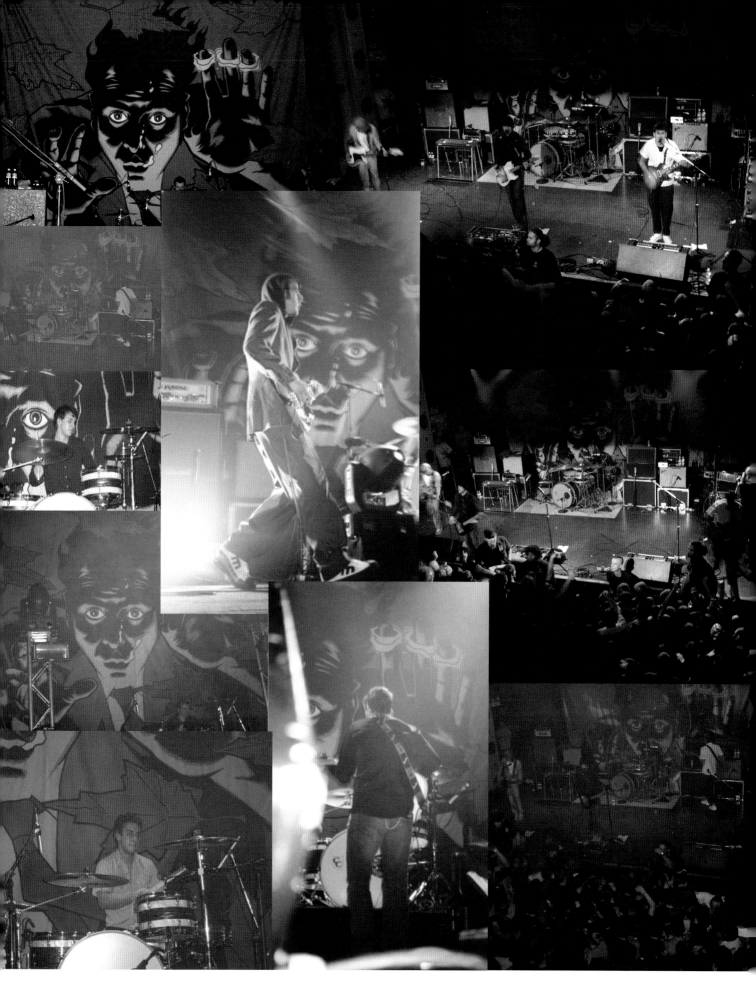

Here are some pics of the Brand New backdrop. I asked anyone who went to their show to send me pictures of the backdrop. In return I sent each person a copy of the poster. I managed to snap off a few myself.
In 2006, I was having drinks in London with folks from Atticus and Brand New's former tour manager. He informed me that the backdrop died a horrible death somewhere in Europe. Ripped beyond repair.

THE NEIN
ZEN SUSHI • LOS ANGELES • 2005
11" x 17" OFFSET PRINT • EDITION OF 50

This was done as a favor for poster artist Casey Burns while he was still a member of the Nein. He asked a bunch of us to design a poster for one of the dates on their tour. Doing work for friends can be more stressful than doing taxes. I wanted to do a good job and not just phone something in. I did this as a mental break while I was working on the 2005 Warped Tour series. It was nice to get away from bright, loud colors to something a bit more subtle. I had actually drawn out the hair and her torso. Check the sketch to the right. But as I was placing it and nudging it around, I set it on top of a black background and left it. Hooray for dumb luck. Fast forward a few years later and Draven shoes made a Brian Ewing *artist shoe* with this graphic.

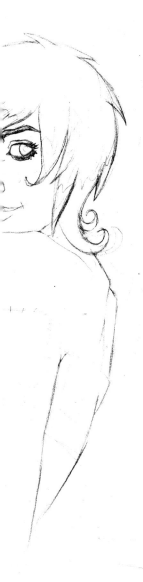

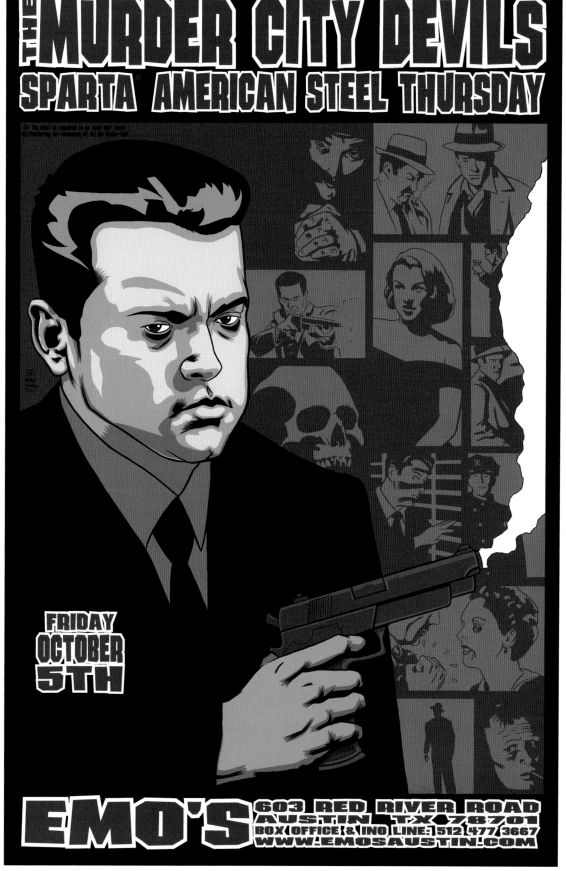

I remember seeing the Murder City Devils at Okayz Corral in Madison, WI. Years before any of you saw them. Yep, I'm gonna be "that guy" for a minute and make you feel less awesome for wearing their shirts but never seeing them live.
For this poster I combined my love for film noir and rock posters of the '90s. Specifically Chantry, Coop, and Kozik.

MURDER CITY DEVILS • SPARTA
AMERICAN STEEL • THURSDAY
EMOS • AUSTIN • 2001
11" x 17" PRINT • EDITION OF 300

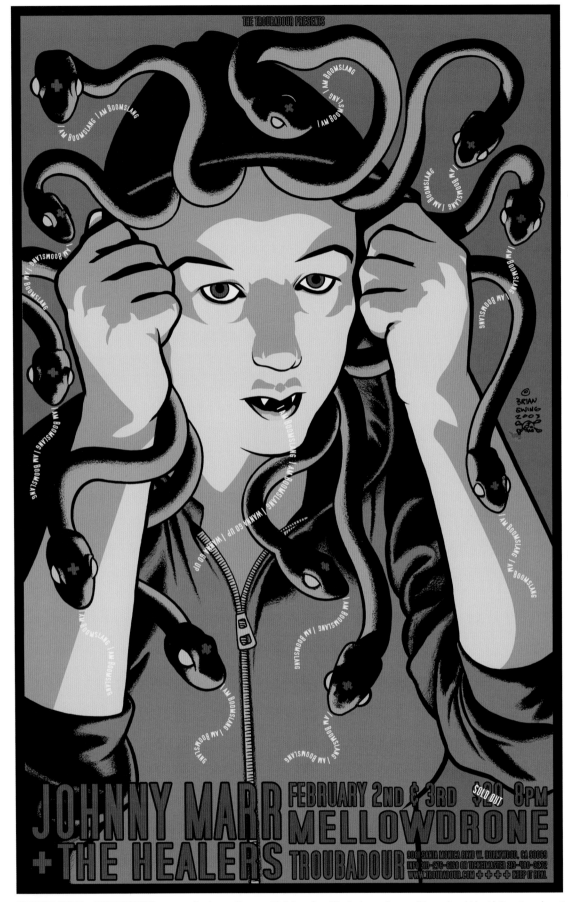

"Brian Ewing's mastery of all things skull and sexy and mondo is peerless. I first encountered Brian's work when I was scouring the Internet, trying to uncover the sinister mind behind some fab rock poster I'd been eyeing. Must've been Johnny Marr. Anyway, when I found the culprit and set my eyes on his larger body of work, my brain immediately switched from art consumer to editor mode. I had to hire this guy! And over the course of time I've had the pleasure of setting his madness loose on the covers of some of our biggest comics. Brian Ewing is the real deal — that mystical point in the universe where rock intersects with fine art, comic books, and 3 A.M. whiskey shots."

—Michael Wright
DC Comics
Skelter Guitarist

JOHNNY MARR + THE HEALERS
MELLOWDRONE
THE TROUBADOUR • HOLLYWOOD • 2003
11" x 17" OFFSET PRINT • EDITION OF 300

Marr's new album was titled *Boomslang*. "I had a dream about a talking snake, which said, 'I am Boomslang, I am Boomslang. I wanna go up, I wanna go up,'" said Marr. "It seemed to go on all night, and I woke up thinking, 'Well, that was pretty weird, even for me.'" I was just gonna draw a snake . . . but then I read that interview and went with this.

This was a weird show to attend. Wall-to-wall hipster Smiths fans. I was sitting at the bar and had a few drinks in me. They were shooting stuff for some live DVD. The music wasn't bad. In the same vein of the Stone Roses. Some dirty, tall dude stops and blocks my view. So I told him to move. He got pissed and left. Later on that night I was introduced to Pete Yorn . . . the guy I told to move. Ah, well. He was in my way.

I belong to an online community called Gigposters.com. There we post our work and brutally critique each other. Below are a few choice comments about this poster. They're awesome.

B_TURNER: don't cry emo dude . . . it's ok, really. she didn't have much of a fashion sense anyway.

LEIA: Poor guy . . . Maybe he couldn't get his hair to lay right.

PHILAARTS: dollar for dollar emo shows are the best.. most entertaining . . . like a baseball game, you spend more time looking at the people sitting around you than watching the actual event.

DWITT : "oh my wretched life . . . I've run out of hair gel . . . I'm lost without you . . . "

KOZIK: 'Bryce joined the Marines! I'll miss him so.'

CONNOR13: "my gauntlet snap broke" "my favorite skin-tight t-shirt has a spot on it."

STANDARD: "+10 Stealth shields ACTIVATED! Now no one can see me!"

KURT: "the skin-tight shirt said vintage on Ebay . . . but it's new.. I can so tell."

GOAD74: Nooooo my tattoos washed off

KURT: "We only dated for two weeks, but she ment everything to me."

DSPRING: "Maryann wants me to go to the dance with her but what will Steven say??? Bwwwaaaaahaaa, I'm so confused, I have to call Gabriel, he'll know what to do."

MAYNARD: "I don't have enough personality to know true sadness. I'm tragic and shallow. and my father doesn't understand me.. boo hoo . . . "

I got so much shit for doing this poster. I am (and I bet you were, too) a huge Jawbreaker fan. So when Jets To Brazil formed, I immediately became a fan of theirs, too. JTB just seemed more dark and depressing. The song "I Typed For Miles" in particular, was just brutal. Reminded me of an ex-girlfriend. The lyrics behind the figure are from that song.

I showed it to my buddy Andrew Bawidamann, and he immediately started laughing and asked why I was poking fun at (some of) the band's fans. Mmmmaybe I was . . . maybe I wasn't.

JETS TO BRAZIL • RETISONIC
THE TROCADERO
PHILADELPHIA • 2003
18" x 24" THREE-COLOR SCREEN PRINT
EDITION OF 300

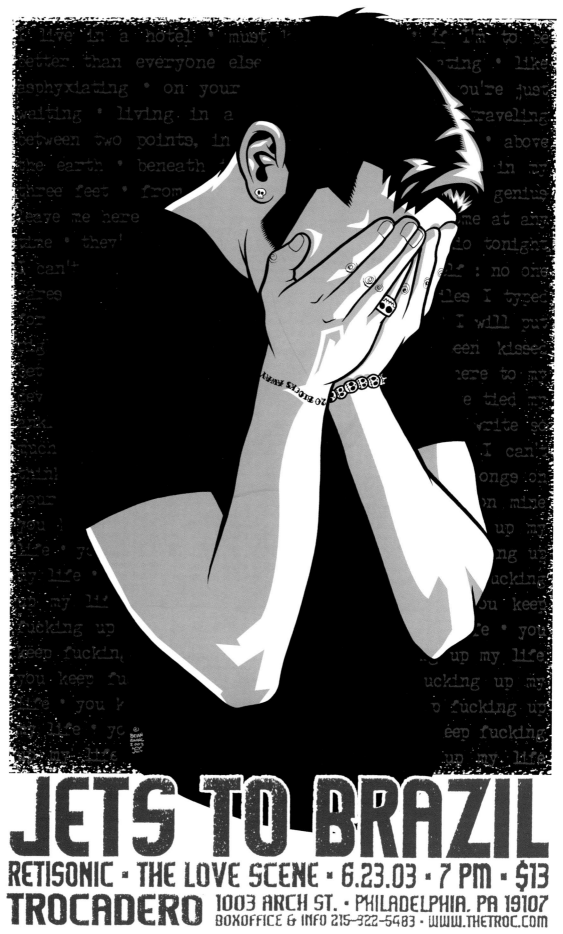

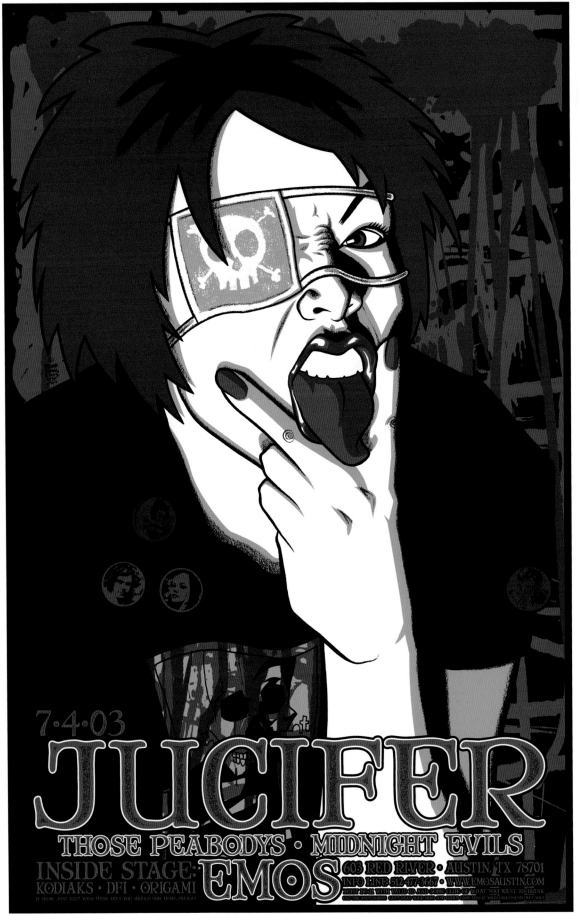

JUCIFER
THOSE PEABODYS •MIDNIGHT EVILS
EMOS • AUSTIN • 2003
18" x 24" FOUR-COLOR SCREEN PRINT • EDITION OF 300

Inspired by looking at some Japanese Harijuku magazines and came up with this. This is the type of girl I'd want to see at a Jucifer show.

My former assistant, Dorothy, posed for this one.

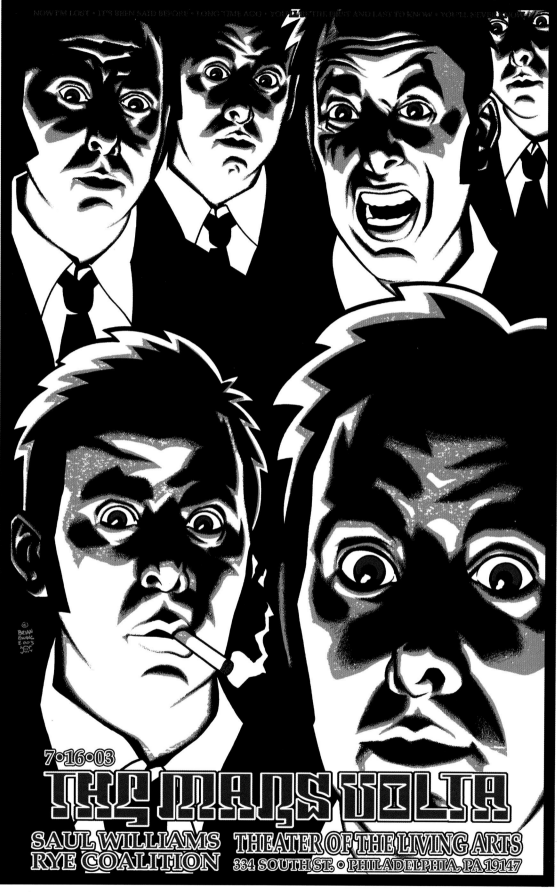

I was really excited to do this poster, even though I only had a few days to get it done. I kinda drew what I was going through at the moment. A billion different moods and trying to get this thing done on time. Kinda like their music. All over the place. I had no choice and had to use the band's logo. Poster was inspired by illustrator Jose Muñoz.

THE MARS VOLTA
SAUL WILLIAMS • RYE COALITION
THEATER OF THE LIVING ARTS • PHILADELPHIA • 2003
18" x 24" SCREEN PRINT • EDITION OF 300

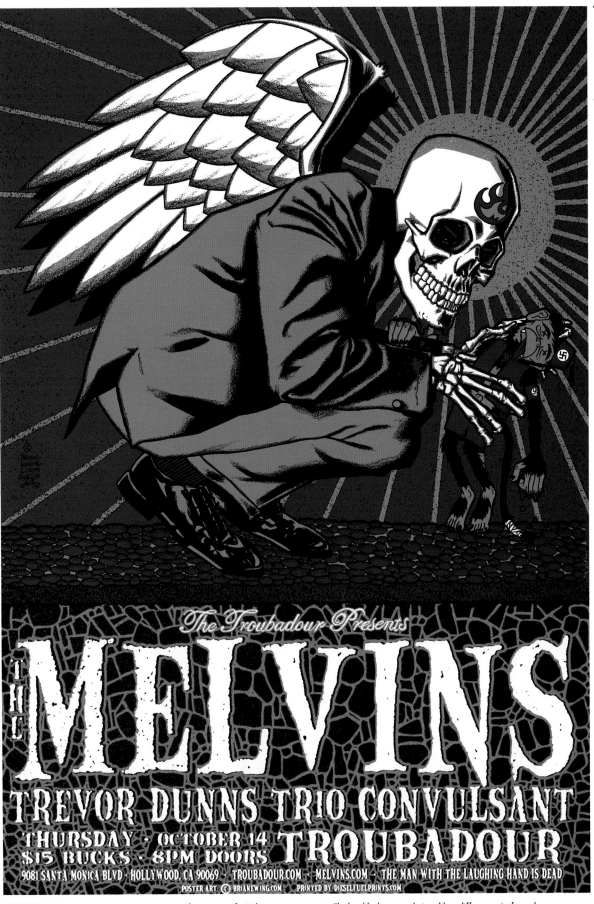

MELVINS
TREVOR DUNN'S TRIO CONVULSANT
THE TROUBADOUR • HOLLYWOOD • 2004
18" x 24" THREE-COLOR SCREEN PRINT
EDITION OF 300

This was part of a Melvins tour-poster series. The band had a poster designed by a different artist for each date they played. I was honored to contribute.
This show actually got cancelled.

Printed by Diesel Fuel Prints.

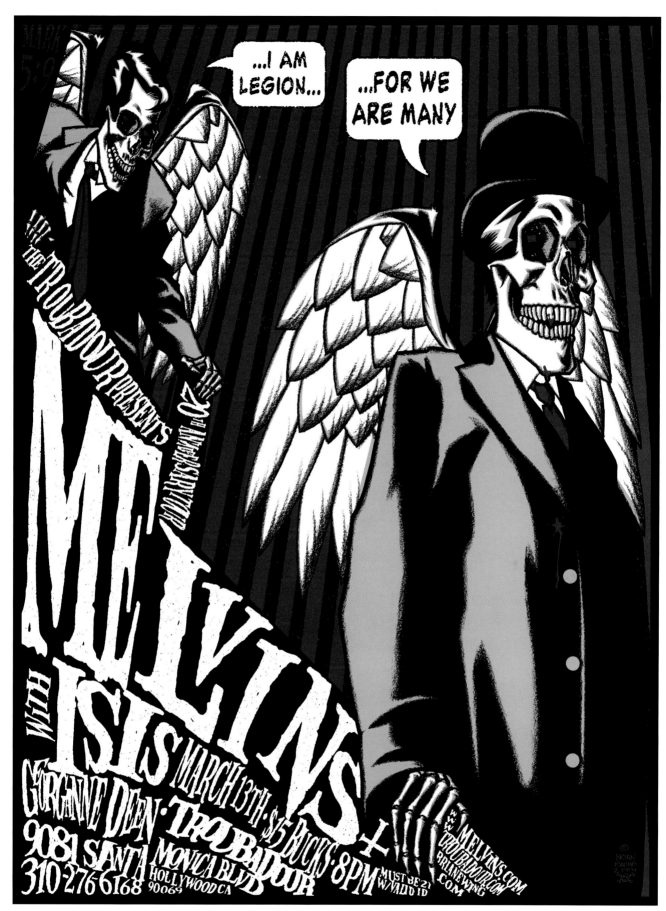

I used to work with Buzz's wife, Mackie, at *Hustler* back in my porno days. She was the art director for *Barely Legal*, and I was in charge of scheduling for the magazine. After a couple of years I decided to quit and pursue Rock Posters full-time. (It's a long story . . . buy me a beer and I'll tell it to ya.) So a week after I quit, I got an invite from Mackie to go to Disneyland with the Melvins. I was stoked because I couldn't wait to tell all my scumbag friends that after years of listening to the band . . . I was going to be riding roller coasters and singing "It's a Small World" with the Melvins. It was also the first time I had been to Disneyland. Mark 5:9 is from the Bible. Look it up.

MELVINS • ISIS
GEORGANNE DEEN
THE TROUBADOUR • HOLLYWOOD • 2004
18" x 24" THREE-COLOR SCREEN PRINT
EDITION OF 300

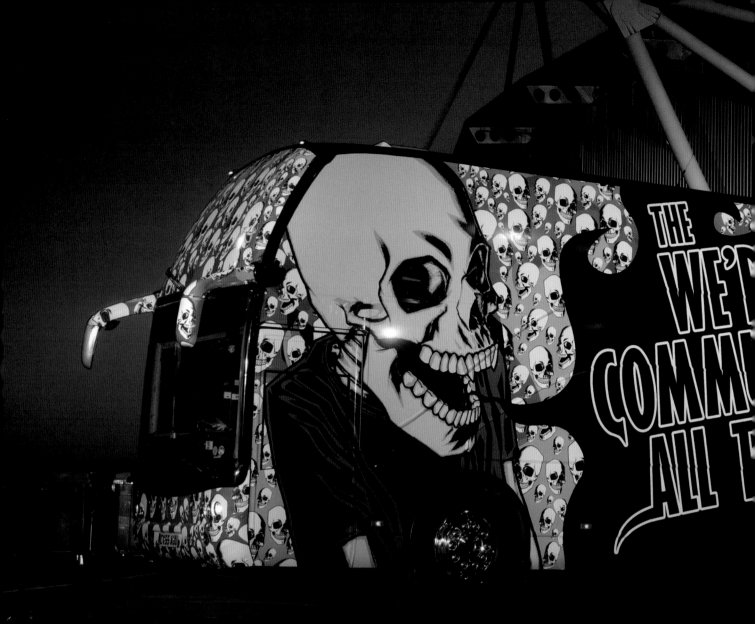

METALLICA: SOME KIND OF MONSTER
SUPER GROUP THERAPY WITH THE WORLD'S BIGGEST
COMING SOON EXCLUSIVELY TO MORE4

channel4.com/more4

**METALLICA TOUR BUS
FOR CHANNEL 4**
TOUR BUS & TUBE POSTERS

I'm still weirded out when I see this. I had just moved to San Francisco when I got this job. Channel 4 Creative hired me to design artwork that would be wrapped on a tour bus and photographed to be used as online, television, and tube station ads throughout London, England. I wish that I could have been there to see it in person. Maybe next time. Maybe Ed will buy me a pint.

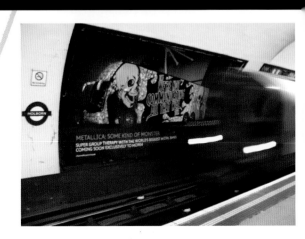

MORE

Adult Entertainment

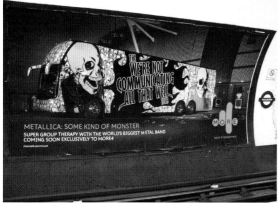

"My relationship with Brian started with a transatlantic call and a brief out-of-the-blue one Autumnal Thursday morning. Less than two weeks later his fantastic skull artwork adorned a tour bus roaring through the leafy Berkshire countryside and was scaring the hell out of the villagers. The local therapists are grateful, and I'm proud to have worked with him. He is charming. He is the Man. He has never bought me a beer."

—Ed Webster
Channel 4 Creative

HELMET • INSTRUCTION
THE TROUBADOUR • HOLLYWOOD • 2004
18" x 24" THREE-COLOR SCREEN PRINT
EDITION OF 300

"There's something about the concert-poster scene where once you get introduced to it . . . it becomes terribly addictive and engrossing. Brian Ewing's art has really gotten a lot of people outside of the *scene* interested in posters, which benefits other artists, dealers, printers, etc. I think we all owe him some thanks. I know I do."

—Mitch Putnam
omgposters.com

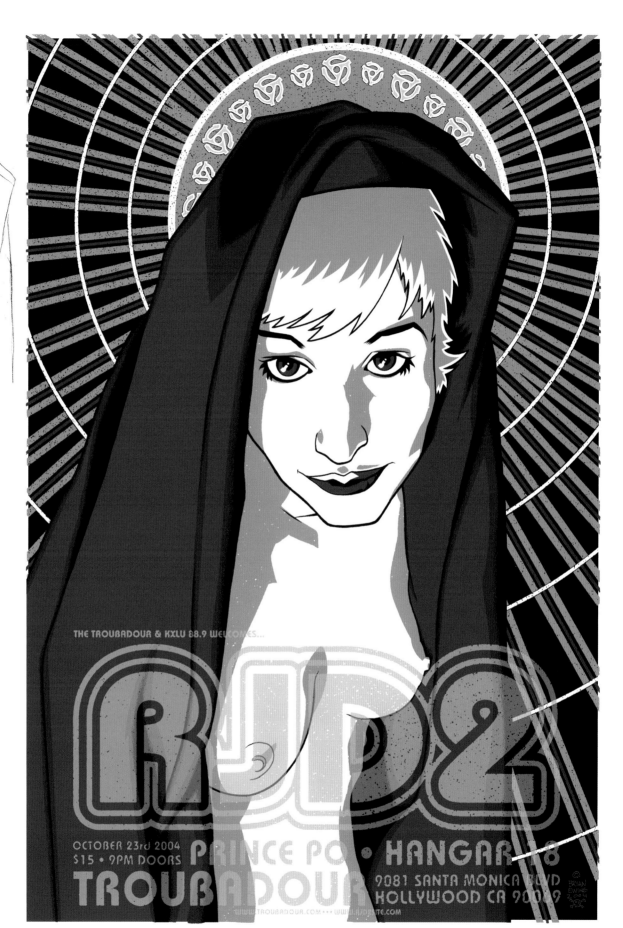

"Brian is who he is because he made it so. I've known him since the first day of high school, when we used to hang out and listen to Death Metal. He works, works, and works. He had an idea in his mind of the sort of artist he wanted to be, and when art school couldn't offer him what he was looking for, he made his own path and has stuck with it ever since. What always surprises me is how much these prints are like him. You can feel his humor, empathy, and craftsmanship when you see them, and that's why they work."

—Steve Somers
Fine Artist
Class of '92

RJD2 • PRINCE PO • HANGAR 18
THE TROUBADOUR • HOLLYWOOD • 2004
18" x 24" THREE-COLOR SCREEN PRINT
EDITION OF 300

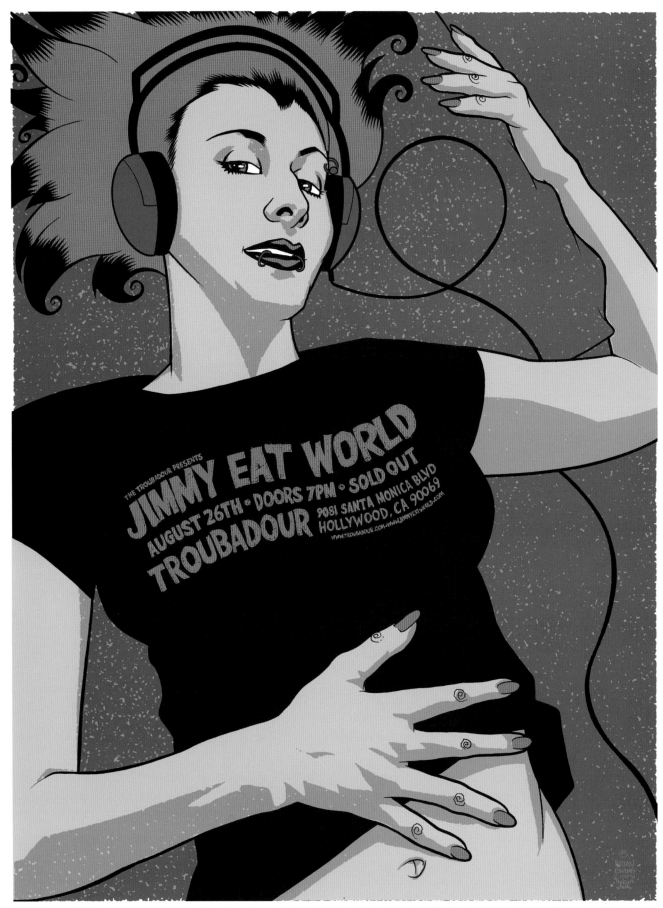

JIMMY EAT WORLD
THE TROUBADOUR • HOLLYWOOD • 2004
18" x 24" 5-COLOR SCREEN PRINT
EDITION OF 300

This band is so damned catchy, I can't help but like them. Sometimes when I'm doing posters, I just wanna draw cute girls. This is a good example. I wanted to do something a bit more happy and sexy. Like, "What does the girl look like who listens to Jimmy Eat World?" My friend Pooka posed for this poster. I had just met her a few weeks prior at the San Diego Comic-Con.

I'm a huge fan of N.E.R.D. and the Neptunes. Being able to do a poster for them was a highlight for me. I went nuts with the text and tried to make it part of the illustration. This has led me to go apeshit and spend hours trying to do something new with how I use text.
I was having issues with showing more of the breasts or not . . . but wanted to try it anyway. So I kept in mind to design it to be cropped. N.E.R.D. have a great Curtis Mayfield/Motown vibe going on in their music. Which I dig. I was trying to go for that. Sexy in a suggestive way.

N.E.R.D. • THE BLACK EYED PEAS
THE ELECTRIC FACTORY • PHILADELPHIA • 2004
18" x 24" FOUR-COLOR SCREEN PRINT
EDITION OF 300

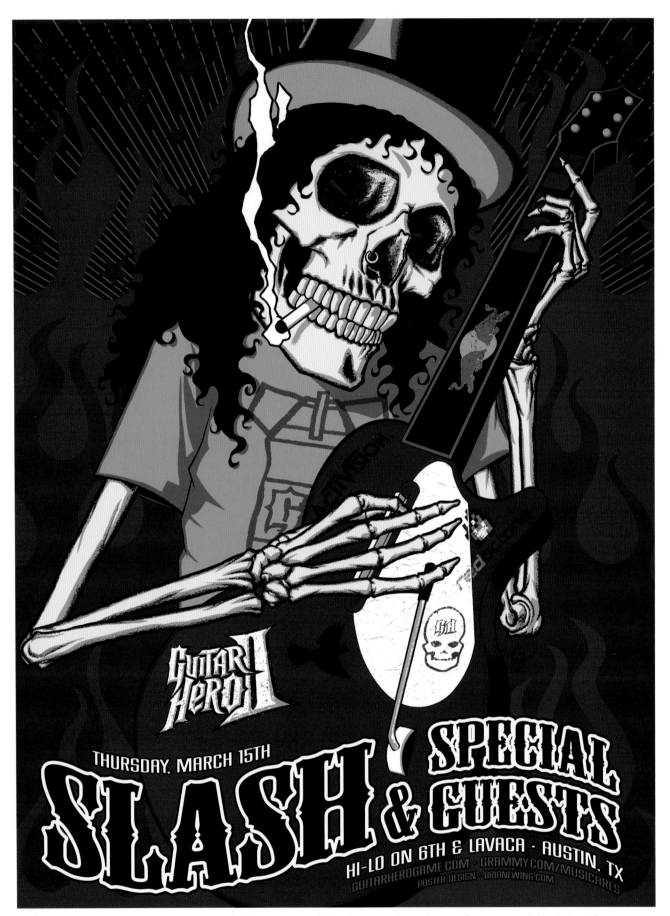

SLASH • GUITAR HERO 2
EMOS • AUSTIN • 2007
18" x 24" SIX-COLOR SCREEN PRINT • EDITION OF 300
75 OF THE EDITION WERE SIGNED AND NUMBERED

The folks at Guitar Hero and Red Bull commissioned me to do a poster for a private party held at SXSW '07. The posters were given away to the attendees and auctioned off to raise money for Music Cares. When I was a kid, my friends and I were huge G 'n' R nerds. This was before CDs, when we had to decide if we'd buy a pack of blank tapes or buy the album. Needless to say, I bought a pack of blanks and dubbed it from my friend Jason.

So . . . I can do an official Guitar Hero poster, but I can't get any of my art into the game? Why, God, why?

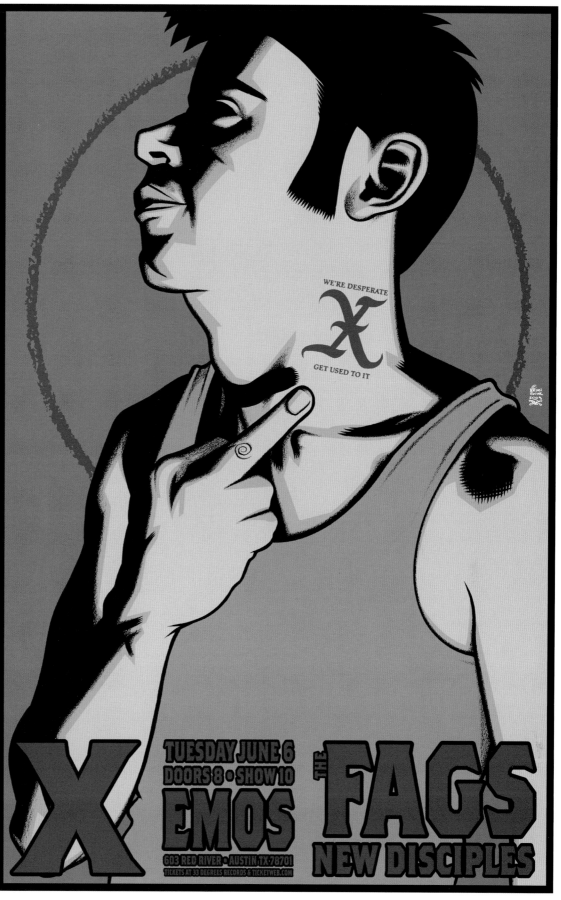

"Brian captures the essence of each band in his posters, using his unique approach and technical expertise. One of X's favorite poster artists!"

—DJ Bonebrake
X

"We're desperate. Get used to it."

X were the soundtrack to my years spent living in LA. To me, they define LA! Drive around and blast their music, and you'll understand what I'm talking about. Whenever I'm in town and I see certain neighborhoods or drive through Mulholland, the radio in my noggin starts playing X. Try to catch them live. Seriously, one of the best shows you'll ever see! Most bands will never be this good.

X • THE FAGS • NEW DISCIPLES
EMOS • AUSTIN • 2003
18" x 24" 5-COLOR SCREEN PRINT
EDITION OF 250

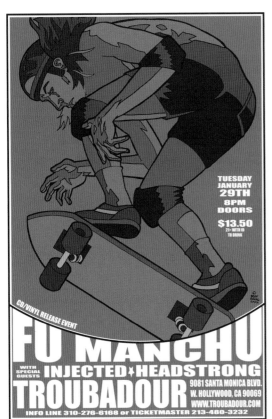

FU MANCHU
INJECTED • HEADSTRONG
THE TROUBADOUR
HOLLYWOOD • 2002
11" x 17" OFFSET PRINT
EDITION OF 300

If Jeff Spicoli was ever in a real band, it would be called Fu Manchu. The epitome of "So-Cal Stoner Rock." I was trying to evoke my older brother and sister's childhood in this one. They had the Nash skateboards with the clay wheels, played with Evel Knievel toys, and rocked the Spirit of '76.
Fu Manchu used this image in the packaging of their 2003 *Go For It Live* album.

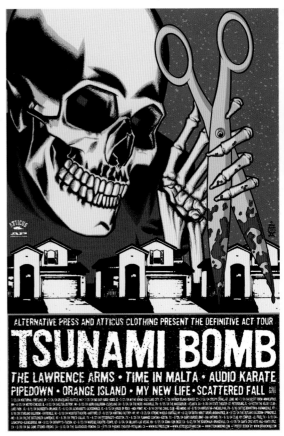

TSUNAMI BOMB
THE LAWRENCE ARMS
TIME IN MALTA
AUDIO KARATE
PIPEDOWN
ORANGE ISLAND
MY NEW LIFE
SCATTERED FALL
TOUR POSTER • 2004
18" x 24" OFFSET PRINT
EDITION OF 300

Brendan Klein/Atticus commissioned me to design Tsunami Bomb's tour poster. I had to crank this out at the same time I was working on the Warped Tour posters. I love you, Red Bull, and I love caffeine. No sleep and fear of deadlines can be great motivators. I geeked out on drawing the hands for this poster and the next Tsunami Bomb poster.

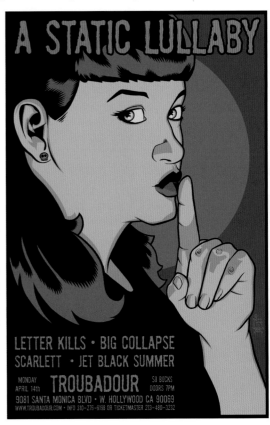

Every poster artist does it – they make a poster based on the band's name. I'm glad I got it out of my system. Or did I? Hmmm . . .
This was one of my favorite pieces at the time. I was experimenting with odd color combos and finally showing some improvement with my inking. Thanks to Jen C., who posed for this.

PUNK ROCK SOCIAL
MOLLY MALONE'S • LOS ANGELES • 2006
11" x 17" OFFSET PRINT

A STATIC LULLABY • LETTER KILLS
BIG COLLAPSE • SCARLETT • JET BLACK SUMMER
THE TROUBADOUR • HOLLYWOOD • 2003
11" x 17" OFFSET PRINT • EDITION OF 300

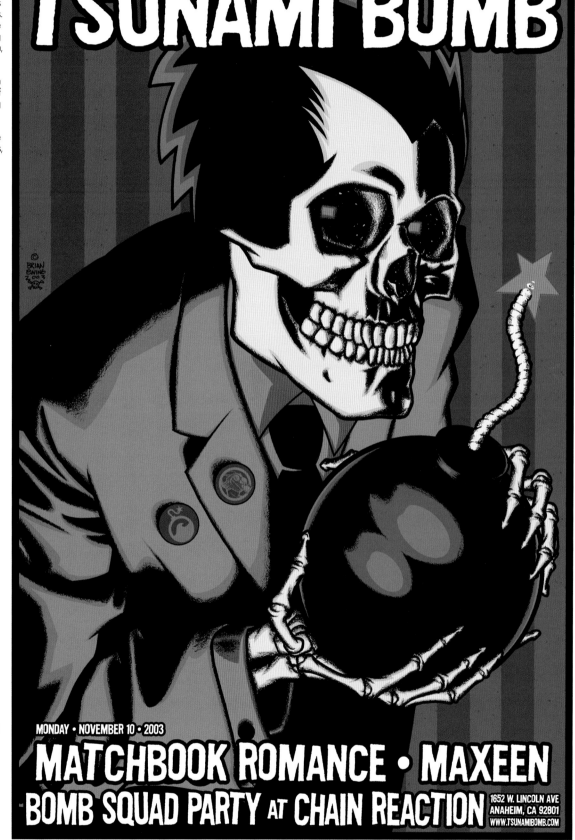

Agent M from Tsunami Bomb asked me to design a poster as a giveaway for the band's fan base, the Bomb Squad. TB were definitely one of those bands who treated their audience well. More bands should do the same and reward the people who go to their shows and buy their albums. And hire me, too. Nudgenudgewinkwink.

TSUNAMI BOMB
MATCHBOOK ROMANCE • MAXEEN
CHAIN REACTION • ANAHEIM • 2003
18" x 24" OFFSET PRINT • EDITION OF 150

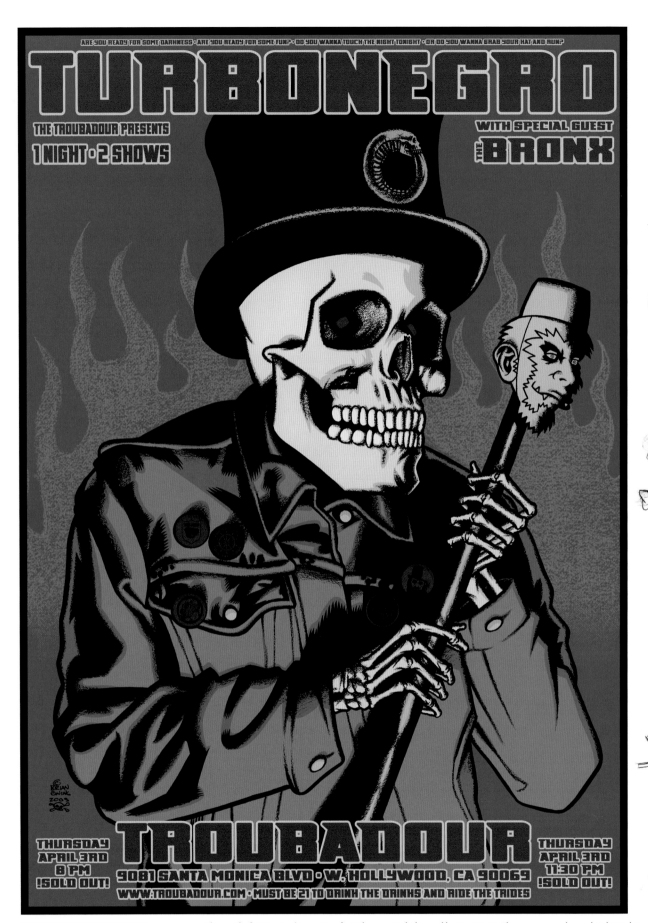

TURBONEGRO • THE BRONX
THE TROUBADOUR • HOLLYWOOD • 2003
18" x 27" OFFSET PRINT • EDITION OF 300

This was the first tour in a loooong time for Turbonegro. Both shows sold out in minutes. The venue was cool enough to let me bring a guest. I ended up taking a friend, since he was the only person to ask me at the time. Then, the day of the concert, everyone and their mom wanted me to get them in. People offered me cash! Women offered me naughty favors!! But I stuck to my guns and took my friend. The motherfucker complained the whole time we were there! Apparently no good deed goes unpunished.
After the show I presented the poster to the band. Really cool guys. They thought it reminded them of the Grateful Dead. Something I hear a lot. Haha!

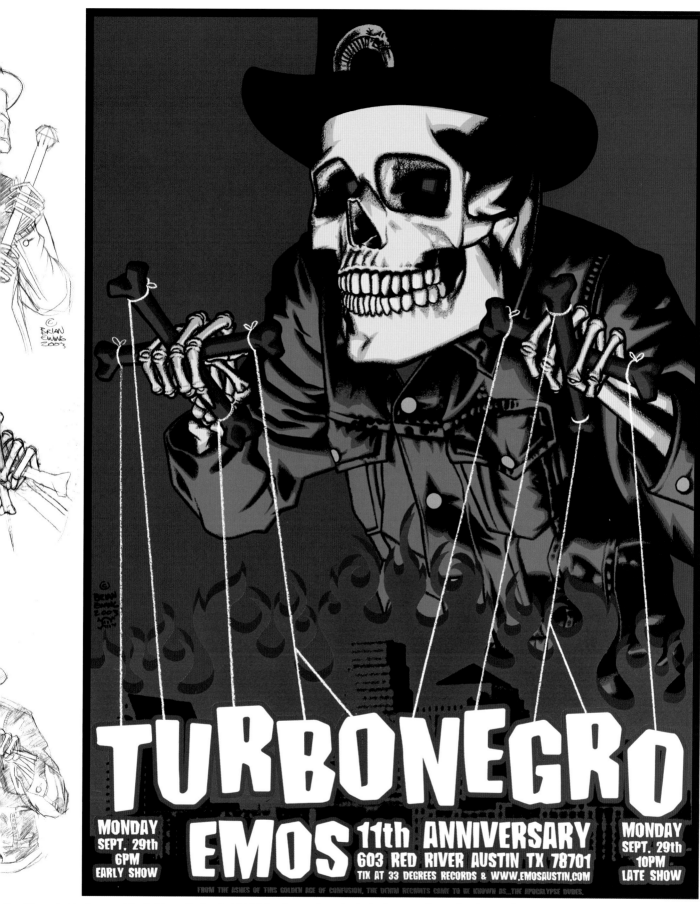

One of the greatest bands . . . ever! You don't know shit about Rock 'n' Roll if you've never listened to this band. Buy *Apocalypse Dudes* right away! This is my second take on their *Denim Demon*.

Graham Williams over at Emo's asked me to do a poster for the club's eleventh anniversary. If you're ever in Austin, go to Emo's. They always have the best showcases during SXSW. One year Graham introduced me to all of the bartenders and said, "See this guy? Do NOT charge him for any drinks!" That weekend was a blur. I still owe Graham and Audrey a portrait.

TURBONEGRO
EMO'S • AUSTIN • 2003
18" x 27" OFFSET PRINT • EDITION OF 300

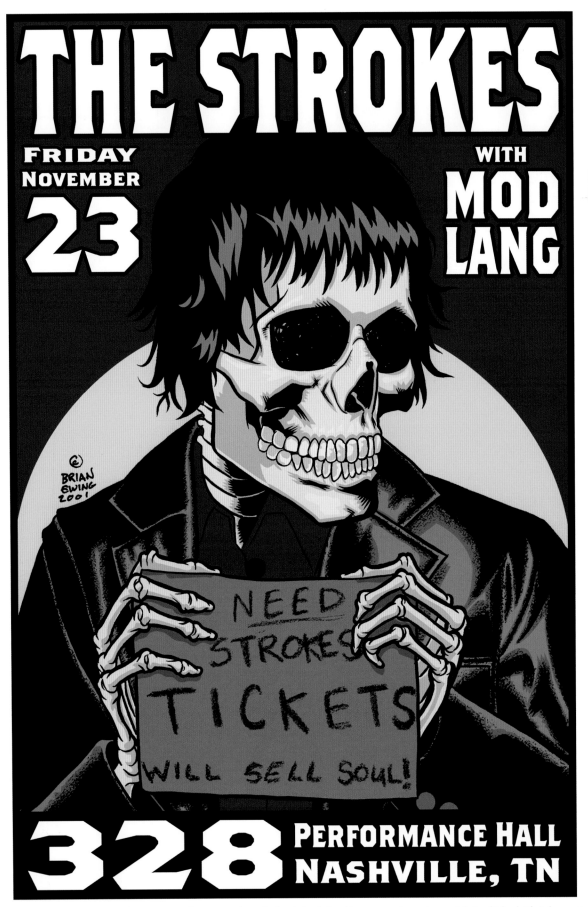

THE STROKES • MOD LANG

THE STROKES • MOD LANG
328 PERFORMANCE HALL • NASHVILLE • 2004
11" x 17" OFFSET PRINT • EDITION OF 300

This poster was done right after the band's first album came out. I remember people hating this band at first, then sporting the well known Strokes shirt a few months later. The inspiration for this came from going to a party in Silverlake that was populated by LA hipsters talking about the band.

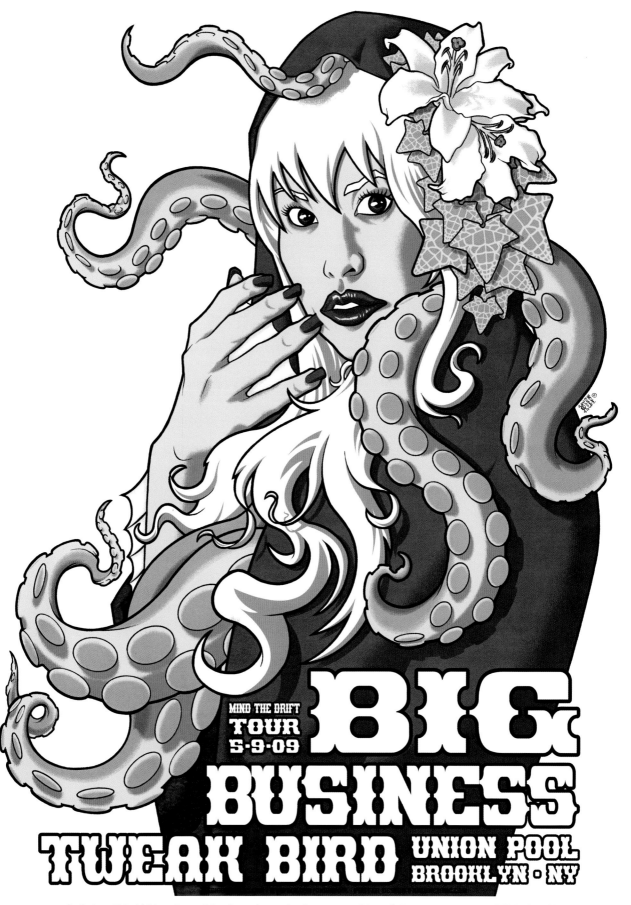

MIND THE DRIFT
TOUR
5-9-09

BIG BUSINESS

TWEAK BIRD UNION POOL BROOKLYN · NY

This was part of a tour series put together by Justin McNeal (of Secret Serpents). I tried to combine my love for pin-up art and Lovecraft. Big Business seemed the perfect band to try that with. I lightened up a bit and made the shading softer and used a lot of over-printing to get the most out of the limited palette. I made a tutorial that you can find on my website.

BIG BUSINESS • TWEAK BIRD
UNION POOL • BROOKLYN • 2009
18" x 24" • FIVE-COLOR SCREEN PRINT
EDITION OF 250

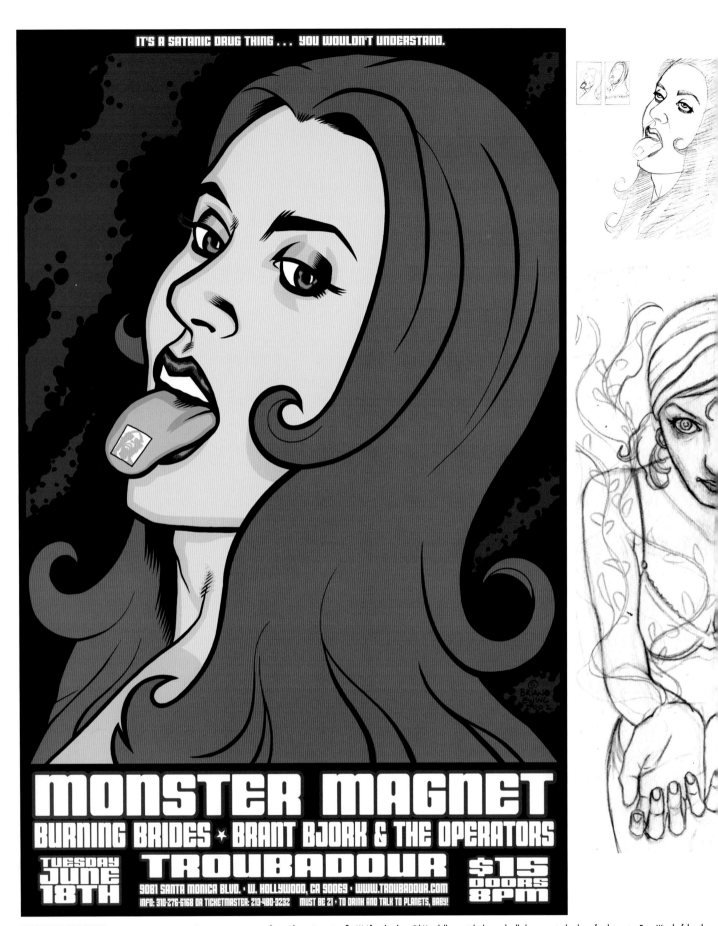

MONSTER MAGNET
BURNING BRIDES • BRANT BJORK

THE TROUBADOUR • HOLLYWOOD • 2002
11" x 17" OFFSET PRINT • EDITION OF 300

Awesome concert . . . ending with a guitar set on fire!!! After the show, Ed Mundell was at the bar and called me over to thank me for the poster. Dave Wyndorf dug the poster too and signed a few for me. It changed my perspective on meeting bands. Not to say they're all nice people, but these dudes definitely were.
Keith Morris was running around showing the poster to everyone. It was weird, because I hadn't met him yet. He ran to Brant Bjork and showed him the poster then showed it to me and ran off. I introduced myself to Keith (singer of one of my favorite bands, the Circle Jerks) and explained that I did the poster. I was in an art show the next day and invited him. He actually showed up! Damn right it was a good week.

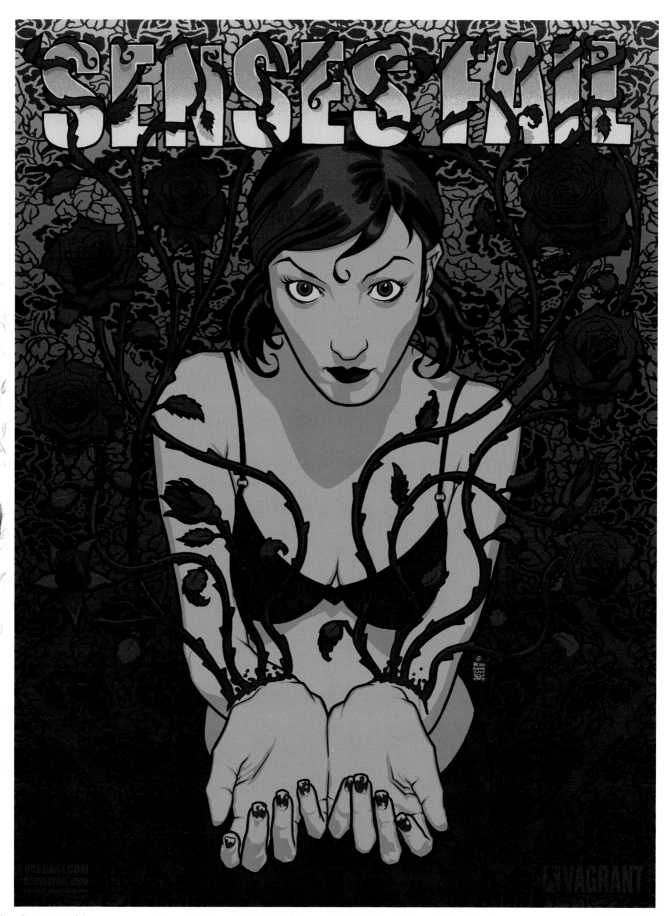

"I've always been 'drawn' to Brian's ladies. Either I wish I could be them, or I want to be part of their badass girl gang."

—Leia Bell
Rock Poster Artist

Vagrant Records commissioned me to design a poster for the release of the new SF album. The only way you could get a copy is by signing up for the Vagrant Fan Club.
I was trying really hard to switch things up a bit and experiment with color and integrating the text with the art. Seems like the beginning of my wanting to draw flowers every chance I can get phase. Kat posed for this.

SENSES FAIL
VAGRANT FAN CLUB EXCLUSIVE • 2006
18" x 24" OFFSET PRINT
EDITION OF 500

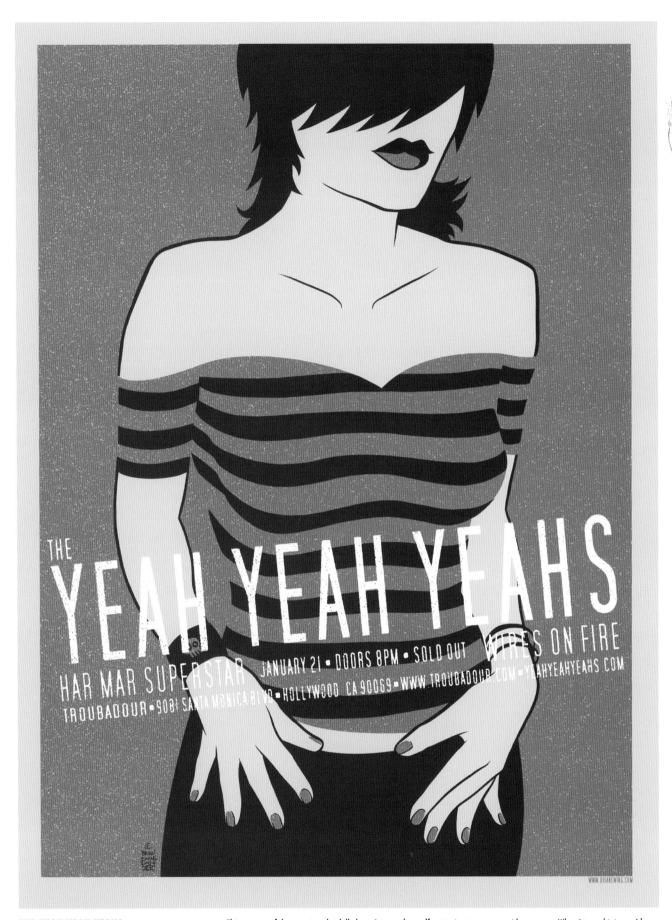

THE YEAH YEAH YEAHS
HAR MAR SUPERSTAR • WIRES ON FIRE
THE TROUBADOUR • HOLLYWOOD • 2004
18" x 24" SCREEN PRINT • EDITION OF 300

This was one of those posters that killed me. I stressed myself out trying to come up with a concept. When I turned it in . . . I knew that everyone was going to hate it. I wanted to simplify my style for this and just work with shapes mostly.
Of all my posters this one sold the fastest. Go figure.

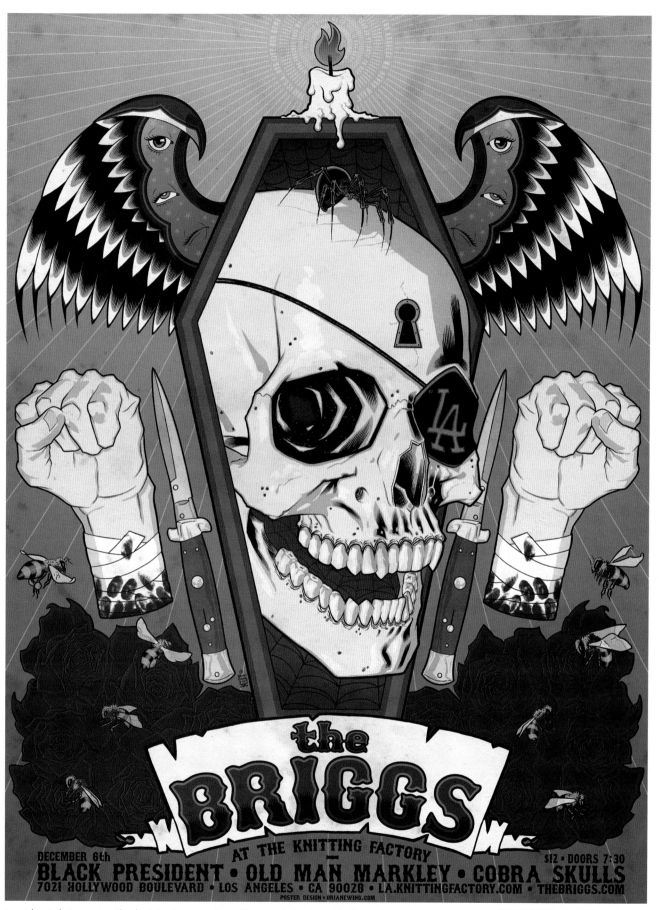

I was itching to design a poster with a classic Americana tattoo theme. I love tattoo flash and especially the ones that are done as a whole piece instead of a bunch of random images on a sheet. Drawing the spider and the wings were the most fun. This was the first poster I designed after moving to Manhattan.

THE BRIGGS • BLACK PRESIDENT
OLD MAN MARKLEY • COBRA SKULLS
THE KNITTING FACTORY • HOLLYWOOD • 2009
18" x 24" OFFSET PRINT • EDITION OF 275

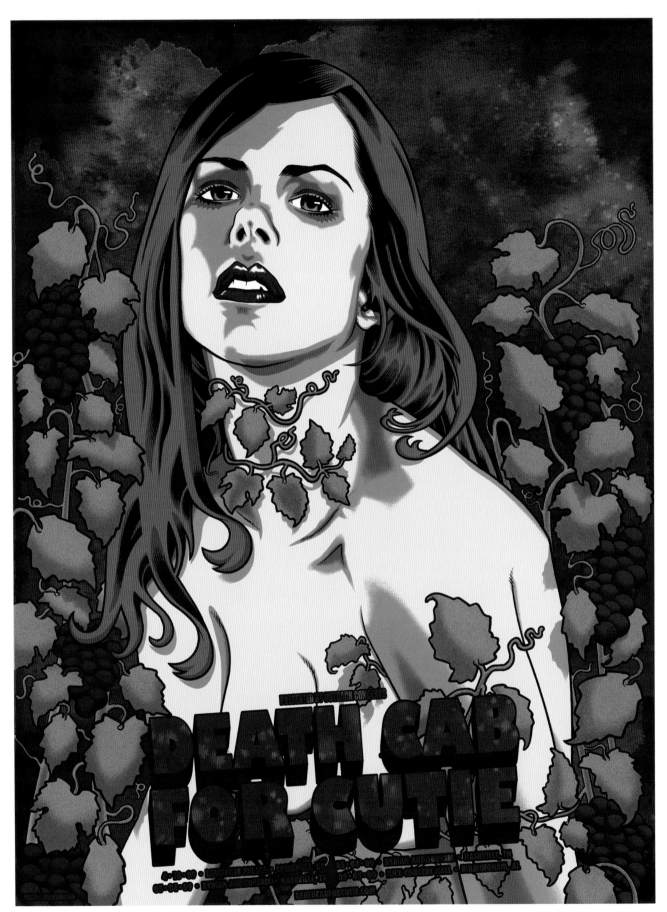

DEATH CAB FOR CUTIE
TOUR POSTER • 2009
18" x 24"
SEVEN-COLOR SCREEN PRINT
EDITION OF 200

I illustrated Death Cab's song "Grapevine Fires" by avoiding some of the clichés that have been employed by designers (who are much better than me). I felt that the depressing, dark, and hip clip-art imagery that's been used for the band's posters wasn't an avenue I wanted to go down. Whenever I think of this band, I think of the cute girls that listen to them. While I was working on this, I found an old box of zip-a-tone. I scanned in one of the patterns and used it for the grape vines. I created the background with abstract watercolor patterns that I made myself. I also used a lot of overprinting to get the most out of my limited palette. And yes . . . you can find a tutorial on how I drew this, on my website. Cuz I'm a nerd.

SIGNING SCHEDULE

BRIAN EWING
SIGNING AT:
12:30

HAWTHORNE HEIGHTS
SIGNING AT:
2:00

ALL AMERICAN REJECTS
SIGNING AT:
4:00

SAMSUNG
WIRELESS

✕ cingular
raising the bar

BUS
15

BUS CALL
1:00 FOR PRODUCTION
BUSES
1:30 FOR EVERYONE
ELSE

AM
LOAD IN 7AM
DOORS 11AM

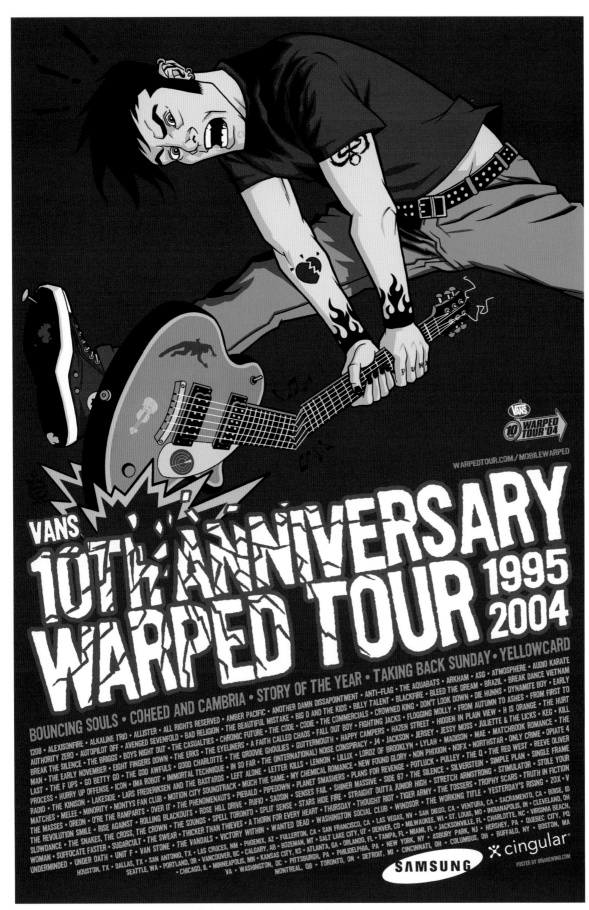

VANS WARPED TOUR '04
U.S. & CANADA TOUR POSTER • 2004
13" x 19" OFFSET PRINT

The first of many posters for the Warped Tour.

I was at Dave Johnson's when I was doing the final pencils on this. He'd grab it, scream, "What the fuck are you doing?" Draw on it, and hand it back to me. Then I'd look at it, scream, "What the fuck did you do?" Erase some of it, and go back to drawing. He helped make the piece better.

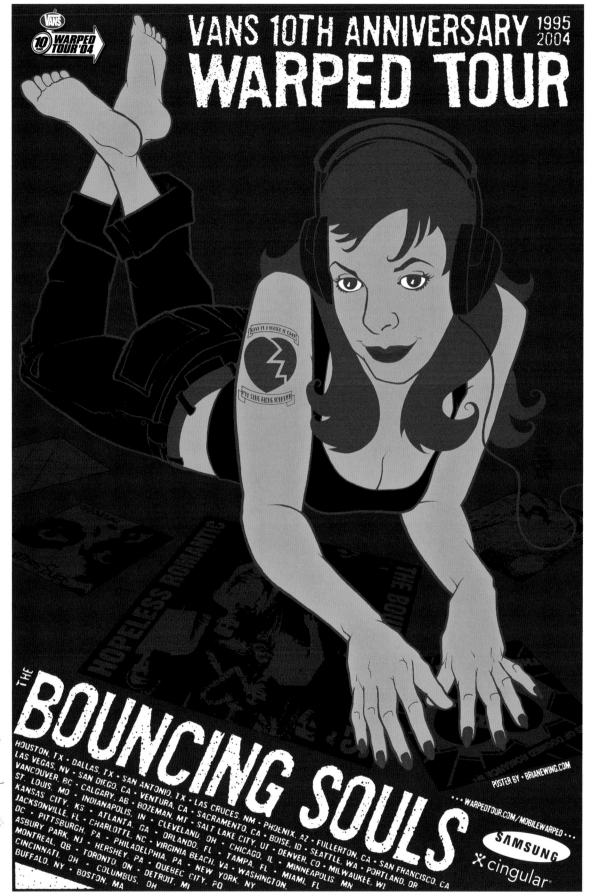

This was the third poster I had done for the Bouncing Souls. Another girl wearing heaphones. On this tour I spent almost every day watching them play. So much fun.

THE BOUNCING SOULS
U.S. & CANADA TOUR POSTER • 2004
13" x 19" OFFSET PRINT

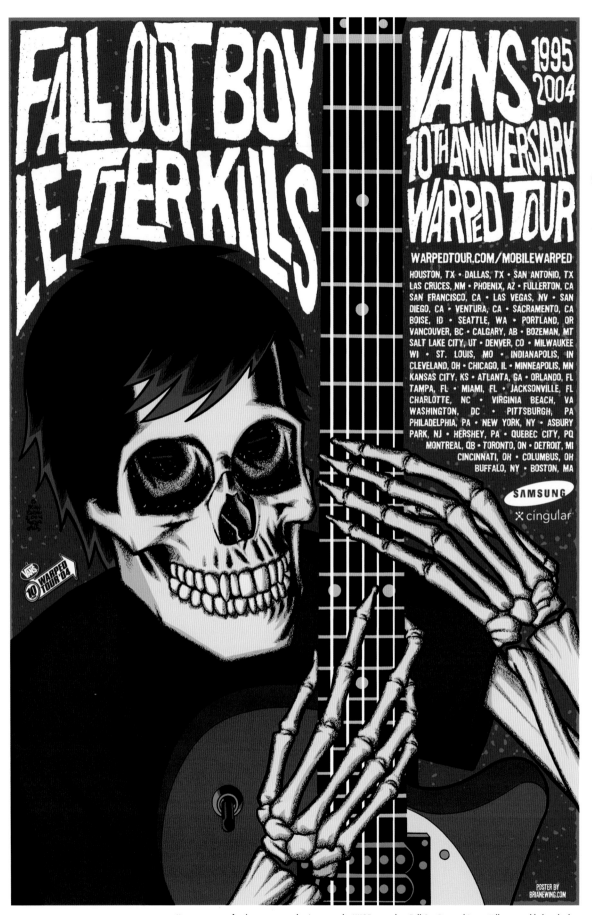

FALL OUT BOY • LETTER KILLS
U.S. & CANADA TOUR POSTER • 2004
13" x 19" OFFSET PRINT

Keep an eye out for these guys . . . they're gonna be HUGE some day. Fall Out Boy and Letter Kills were added at the last minute to the project. That's why they're not featured on the main poster. Guess which band they replaced?

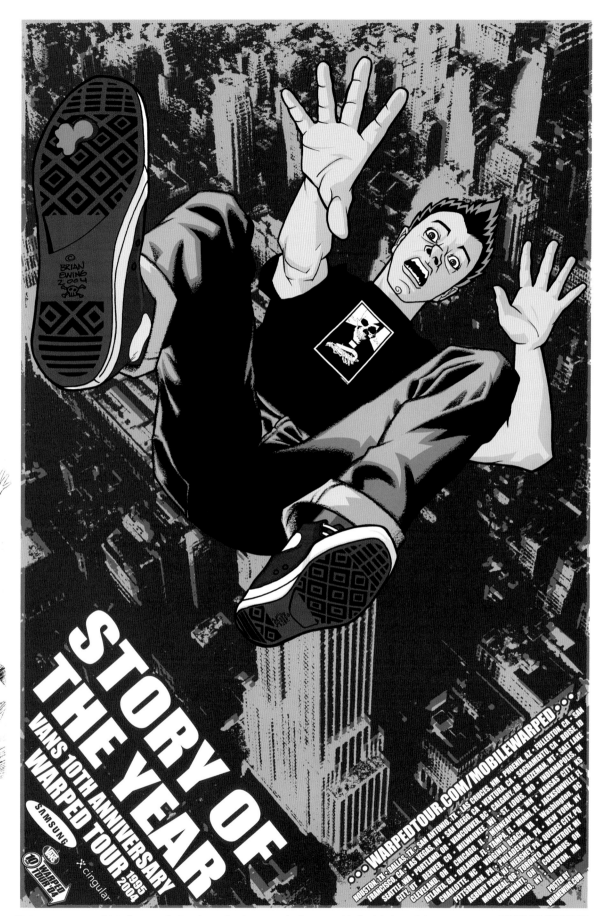

This is my interpretation of their album cover for *Page Avenue*. I've always wanted to draw a scene like this. I think it might have been comic book covers by George Perez or Mike Zeck that burned the idea into my nugget.

STORY OF THE YEAR
U.S. & CANADA TOUR POSTER • 2004
13" x 19" OFFSET PRINT

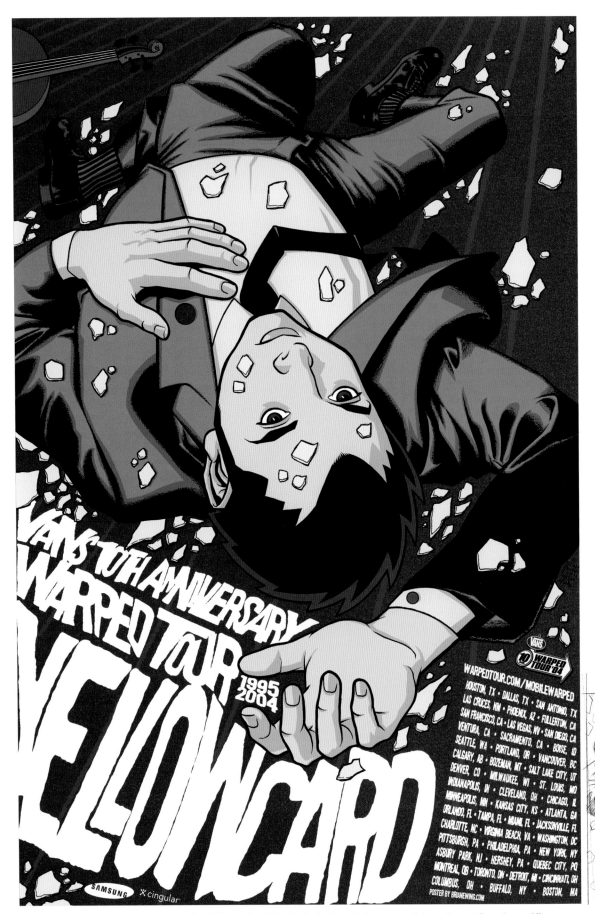

YELLOWCARD
U.S. & CANADA TOUR POSTER • 2004
13" x 19" OFFSET PRINT

This was based off a scene from the band's video for their single "Ocean Avenue," where a character's fate is shown in different ways. If you look closely you'll see a lamb button on the guy's jacket. Brand New also used the same lamb in one of their videos. Sometimes inspiration for a poster comes from different places. The band requested I draw a violin in the poster.

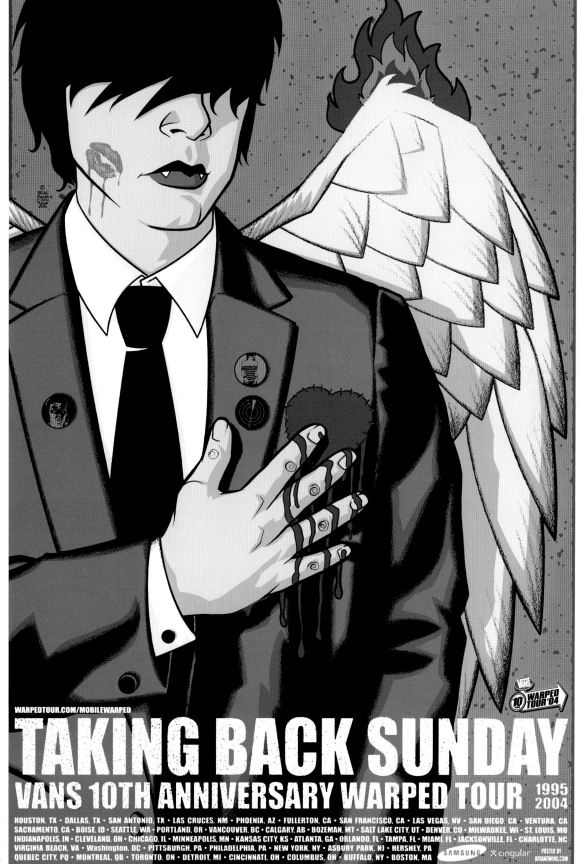

WARPEDTOUR.COM/MOBILEWARPED

TAKING BACK SUNDAY
VANS 10TH ANNIVERSARY WARPED TOUR 1995 2004

HOUSTON, TX · DALLAS, TX · SAN ANTONIO, TX · LAS CRUCES, NM · PHOENIX, AZ · FULLERTON, CA · SAN FRANCISCO, CA · LAS VEGAS, NV · SAN DIEGO, CA · VENTURA, CA
SACRAMENTO, CA · BOISE, ID · SEATTLE, WA · PORTLAND, OR · VANCOUVER, BC · CALGARY, AB · BOZEMAN, MT · SALT LAKE CITY, UT · DENVER, CO · MILWAUKEE, WI · ST. LOUIS, MO
INDIANAPOLIS, IN · CLEVELAND, OH · CHICAGO, IL · MINNEAPOLIS, MN · KANSAS CITY, KS · ATLANTA, GA · ORLANDO, FL · TAMPA, FL · MIAMI, FL · JACKSONVILLE, FL · CHARLOTTE, NC
VIRGINIA BEACH, VA · Washington. DC · PITTSBURGH, PA · PHILADELPHIA, PA · NEW YORK, NY · ASBURY PARK, NJ · HERSHEY, PA
QUEBEC CITY, PQ · MONTREAL, QB · TORONTO, ON · DETROIT, MI · CINCINNATI, OH · COLUMBUS, OH · BUFFALO, NY · BOSTON, MA

SAMSUNG ✕ cingular POSTER BY
BRIANEWING.COM

This is another piece of art that took on a life of its own. I originally submitted this to the band for their *Where You Want To Be* album. The band felt that it wouldn't work for an album cover, so it sat in my sketchbook. Fast forward and one of the bands I end up doing a poster for is . . . Taking Back Sunday. I submitted this again, and it became the poster it is now. Since then I've been fortunate to have hung out with Adam and Eddie from the band. One year, my buddy Ashley took me to Adam's birthday party. There he told me that his roommate had a ton of my posters hanging up in their apartment. That made my night. Kids have had this tattooed on them! They've even dressed up as the character for Halloween. I'm floored whenever I see my work tattooed on someone. I never think it would have a life beyond just being a poster. It's humbling.

TAKING BACK SUNDAY
U.S. & CANADA TOUR POSTER • 2004
13" x 19" OFFSET PRINT

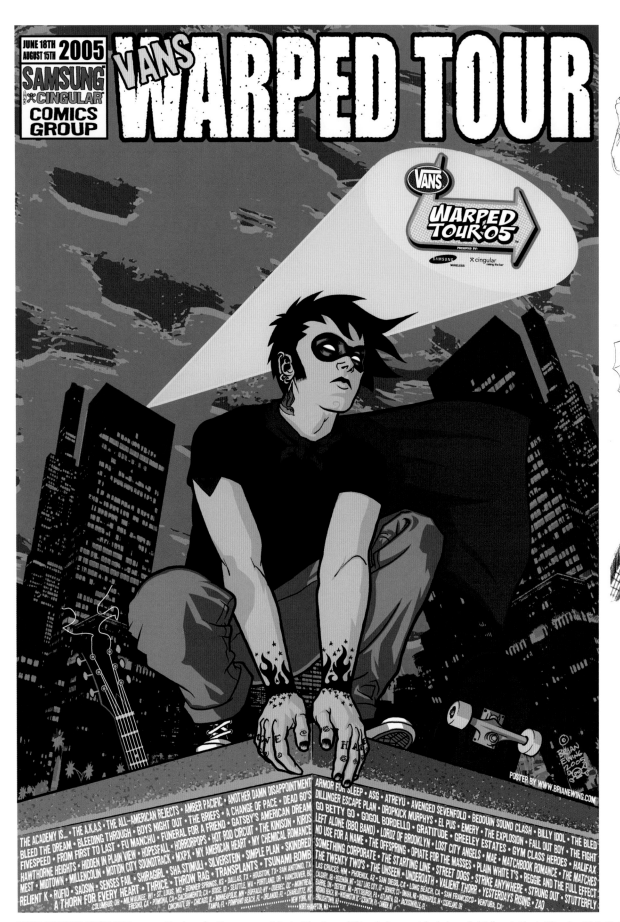

VANS WARPED TOUR '05
U.S. & CANADA TOUR POSTER • 2005
13" x 19" OFFSET PRINT

The theme for this tour was comic books. When I was a kid I worked at a comic-book shop called Collector's Edge in Milwaukee, WI. So I lucked out to be able to work on the tour for a second year and be able to indulge in my love for comic books. I treated each poster as if it were a comic book cover.

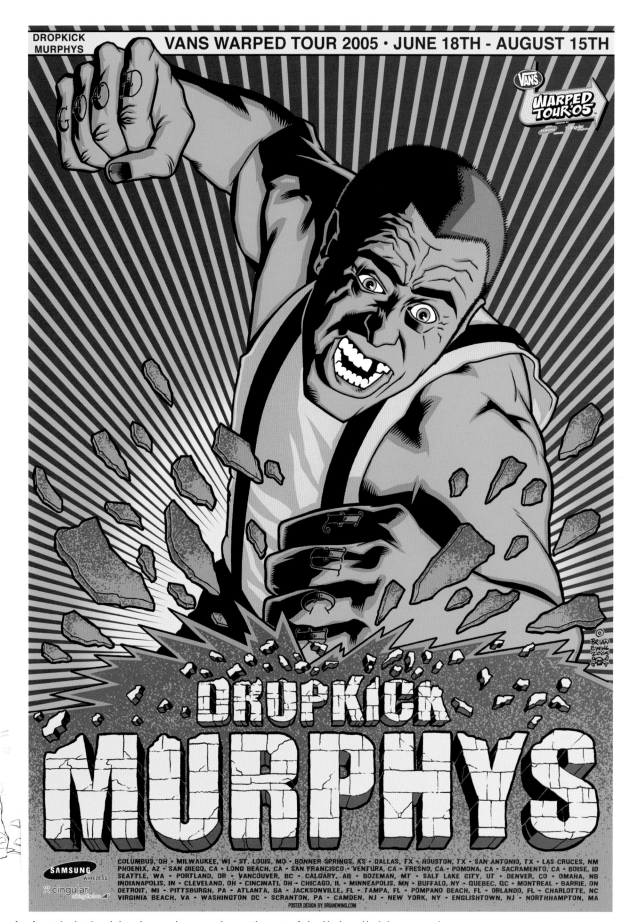

Dropkick Murphys are one of my favorite bands. I'd watch them play every day I was on the tour. Whenever I'm feeling like the world is kicking my ass, I throw on one of their albums and wish I had some beer in the fridge or was at the bar hanging with friends.

For this poster I wanted to try and emulate an *Incredible Hulk* cover. The design of the cover at least. I thought it would be funny and fitting to have a skinhead getting his Hulk on and smashing through the band's name. I even went as far as trying to make the band's name look like the old *Hulk* logo. I didn't bother turning in different ideas; I was really set on this.

DROPKICK MURPHYS
U.S. & CANADA TOUR POSTER • 2005
13" x 19" OFFSET PRINT

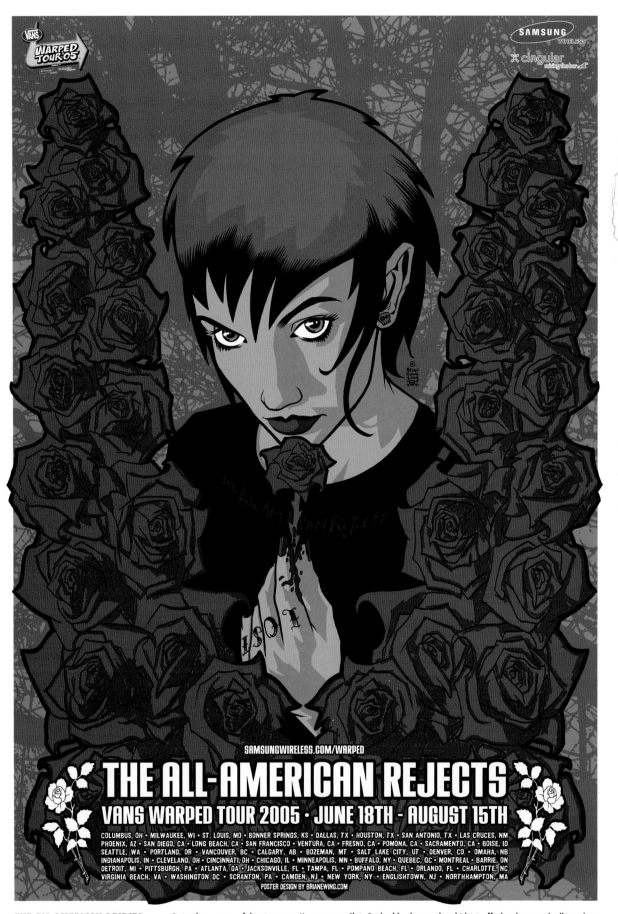

THE ALL-AMERICAN REJECTS
U.S. & CANADA TOUR POSTER • 2005
13" x 19" OFFSET PRINT

Seriously . . . some of the nicest guys I've ever met. Chris Gaylor (the drummer) and I hit it off when he started talking about Metal and how one of his friends looked exactly like the girl in the poster I drew for Neurosis. A few weeks later she emailed me a picture of herself and . . . no shit she looked exactly like the girl in the poster. So weird.

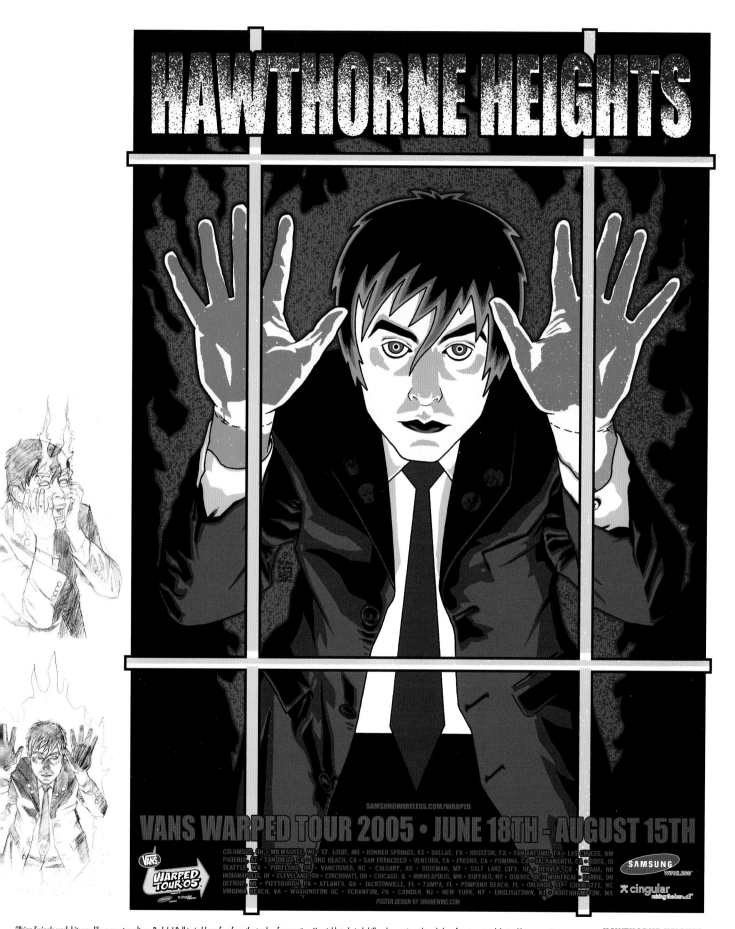

"Brian Ewing's work hits you like a counter-culture, Rock 'n' Roll train blown free from the tracks of convention. He wields technical skill and an eminent knowledge of poster art and design like a reaper's scythe. Underneath are equal doses of passion, energy, and the cleverness to see beyond the obvious. He has a vision, and that vision is a truly unique and eclectic tour de force born out of rock therapy."

—Tim Bradstreet
Cover Artist
Punisher/Hellblazer

HAWTHORNE HEIGHTS
U.S. & CANADA TOUR POSTER • 2005
13" x 19" OFFSET PRINT

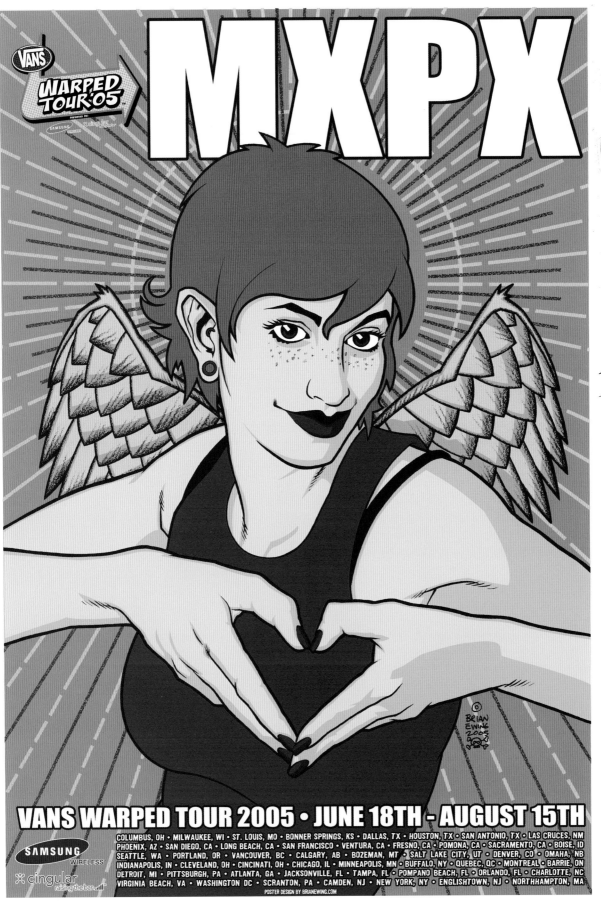

MXPX
U.S. & CANADA TOUR POSTER • 2005
13" x 19" OFFSET PRINT

"I could gush all day about how great Brian is. He'll loan you money, get you into the back door of exclusive soirees, maybe even order several of his groupies to give you a massage after a tough day . . . But you better make damn sure he has his morning coffee or things will get very, very ugly. Do NOT call to bother him for a critique of ongoing work — unless you are willing to hear the truth. Do not try to swipe something and pass it off as your own . . . Brian knows all (REALLY)."

—Andrew Bawidamann
Pin-Up Artist

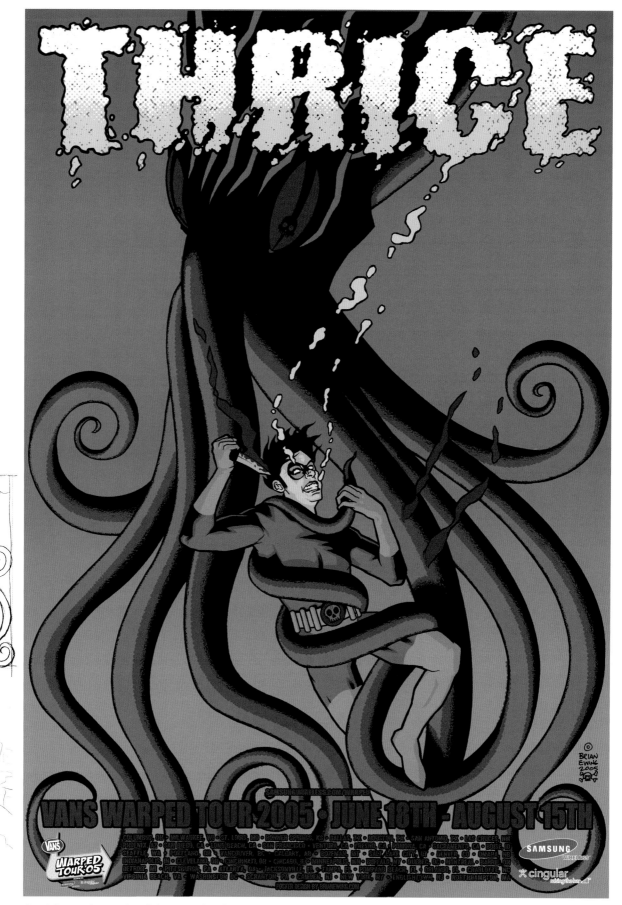

The band requested I draw something dark . . . Me draw something *dark*? So I turned in a few sketches involving zombies crawling out of the grave with an EC Comics vibe to it. The band got back to me and said they meant, "dark as in a giant squid or octopus. No skulls." So I threw a bunch of skulls in there anyway.

THRICE
U.S. & CANADA TOUR POSTER • 2005
13" x 19" OFFSET PRINT

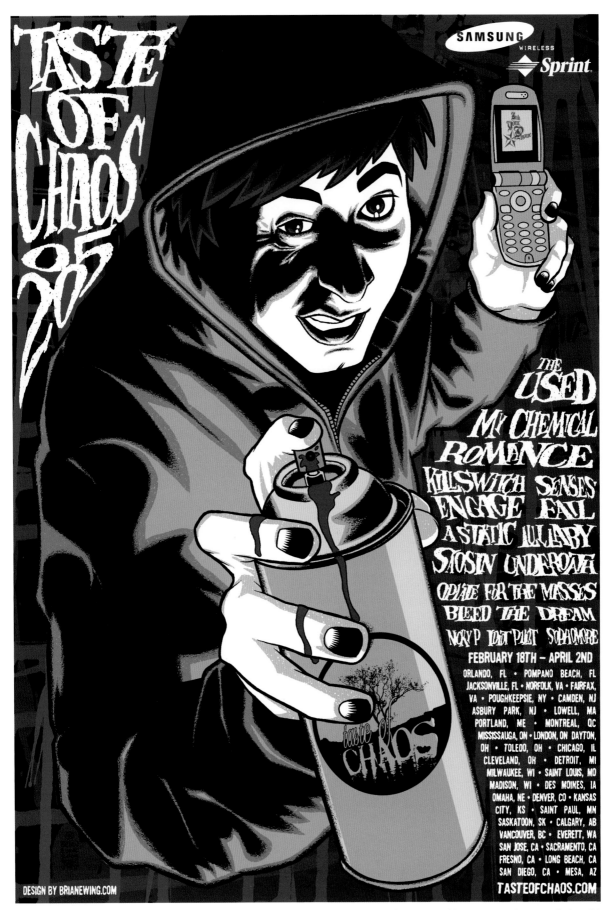

TASTE OF CHAOS '05

THE USED
MY CHEMICAL ROMANCE
KILLSWITCH ENGAGE SENSES FAIL
A STATIC LULLABY
STOSIN UNDEROATH
OPIATE FOR THE MASSES
BLEED THE DREAM
NORA P LOST PLET SOPHOMORE

FEBRUARY 18TH – APRIL 2ND

ORLANDO, FL • POMPANO BEACH, FL
JACKSONVILLE, FL • NORFOLK, VA • FAIRFAX,
VA • POUGHKEEPSIE, NY • CAMDEN, NJ
ASBURY PARK, NJ • LOWELL, MA
PORTLAND, ME • MONTREAL, QC
MISSISSAUGA, ON • LONDON, ON DAYTON,
OH • TOLEDO, OH • CHICAGO, IL
CLEVELAND, OH • DETROIT, MI
MILWAUKEE, WI • SAINT LOUIS, MO
MADISON, WI • DES MOINES, IA
OMAHA, NE • DENVER, CO • KANSAS
CITY, KS • SAINT PAUL, MN
SASKATOON, SK • CALGARY, AB
VANCOUVER, BC • EVERETT, WA
SAN JOSE, CA • SACRAMENTO, CA
FRESNO, CA • LONG BEACH, CA
SAN DIEGO, CA • MESA, AZ

TASTEOFCHAOS.COM

DESIGN BY BRIANEWING.COM

TASTE OF CHAOS
U.S. & CANADA TOUR POSTER • 2004
13" x 19" OFFSET PRINT

I'm sneaking this in with the Warped Tour posters, because it's pretty much an extension of the tour. Same people put it together but with heavier bands. I got the opportunity to travel with the tour to do signings. It afforded me the chance to see parts of the country I never thought I would. I had way too much fun. Every day I was on the tour I had the opportunity to watch the bands from the side of the stage. It was awesome! I can't remember which city it was, I think it was in Camden, NJ, they booked us all rooms in a hotel. Everyone from the road crew and the bands were staying there. We ended up getting there later than most of the other buses. I got my key and went to my room only to find a bunch of people already in there. It was the guys from A Static Lullaby saying "Hey Brian, what's up?" Like I was dropping by to visit. The room got double-booked! Fuck that shit. I needed sleep! I called the tour manager, Nick, and he somehow found another room for me. Sorry, dudes.

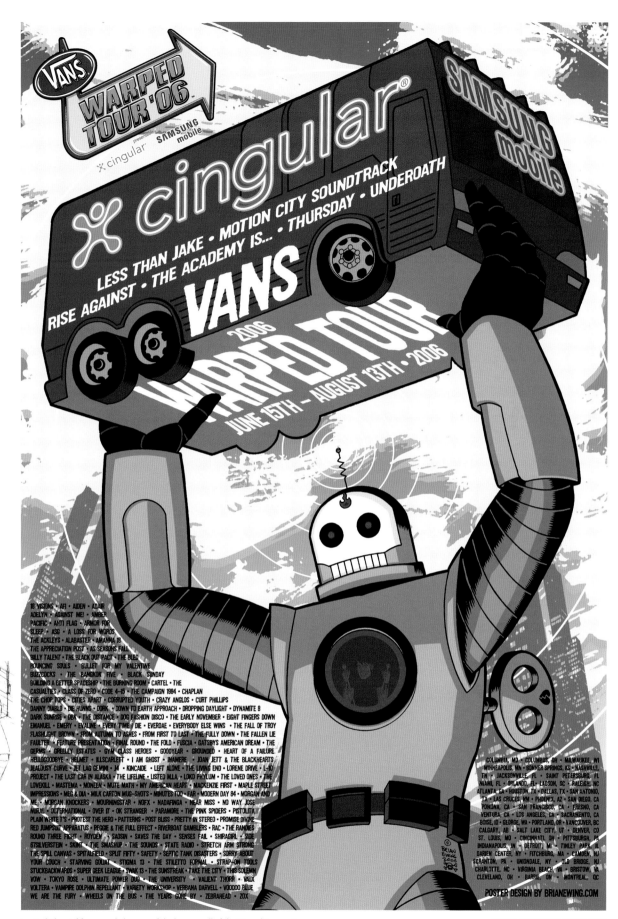

18 VISIONS • AFI • AIDEN • ADAIR
ADELYN • AGAINST ME! • AMBER
PACIFIC • ANTI FLAG • ARMOR FOR
SLEEP • ASG • A LOSS FOR WORDS
THE ACKLEYS • ALABASTER • AMANDA 18
THE APPRECIATION POST • AS SEASONS FALL
BILLY TALENT • THE BLACK OUT PACT • THE BLED
BOUNCING SOULS • BULLET FOR MY VALENTINE
BUZZCOCKS • THE BANGKOK FIVE • BLACK SUNDAY
BUILDING A BETTER SPACESHIP • THE BURNING ROOM • CARTEL • THE
CASUALTIES • CLASS OF ZERO • CODE 4-15 • THE CAMPAIGN 1984 • CHAPLAN
THE CHOP TOPS • CITIES APART • CORRUPTED YOUTH • CRAZY ANGLOS • CURT PHILLIPS
DANNY DIABLO • DIE HUNNS • DORK • DOWN TO EARTH APPROACH • DROPPING DAYLIGHT • DYNAMITE 8
DARK SUNRISE • DBK • THE DISTANCE • DOG FASHION DISCO • THE EARLY NOVEMBER • EIGHT FINGERS DOWN
EMANUEL • EMERY • EVALINE • EVERY TIME I DIE • EVERDAE • EVERYBODY ELSE WINS • THE FALL OF TROY
FLASHLIGHT BROWN • FROM AUTUMN TO ASHES • FROM FIRST TO LAST • THE FULLY DOWN • THE FALLEN LIE
FAULTER • FEATURE PRESENTATION • FINAL ROUND • THE FOLD • FUSCIA • GATSBY'S AMERICAN DREAM • THE
GERMS • GREELEY ESTATES • GYM CLASS HEROES • GOODYEAR • GROUNDED • HEART OF A FAILURE
HELLOGOODBYE • HELMET • ILLSCARLETT • I AM GHOST • INVAMERE • JOAN JETT & THE BLACKHEARTS
JEALOUSY CURVE • JET LAG GEMINI • J4 • KINCAIDE • LEFT ALONE • THE LIVING END • LORENE DRIVE • L-10
PROJECT • THE LAST CAR IN ALASKA • THE LIFELINE • LISTED MLLA • LOKO PHYLUM • THE LOVED ONES • THE
LOVEKILL • MASTEMA • MONEEN • MUTE MATH • MY AMERICAN HEART • MACKENZIE FIRST • MAPLE STREET
IMPRESSIONS • MEG & DIA • MILK CARTON MUG-SHOTS • MINUTES TOO FAR • MODERN DAY 84 • MORGAN AND
ME • MORGAN KNOCKERS • MOURNINGSTAR • NOFX • NADAFINGA • NEAR MISS • NO WAY JOSE
MURAL • OUTERNATIONAL • OVER IT • OK STRANGER • PARAMORE • THE PINK SPIDERS • PISTOLITA
PLAIN WHITE T'S • PROTEST THE HERO • PATTERNS • POST BLISS • PRETTY IN STEREO • PROMISE DIVINE
RED JUMPSUIT APPARATUS • REGGIE & THE FULL EFFECT • RIVERBOAT GAMBLERS • RAC • THE RANDIES
ROUND THREE FIGHT • ROYDEN • SAOSIN • SAVES THE DAY • SENSES FAIL • SHIRAGIRL • SIDE
6TSILVERSTEIN • SKINT • THE SMASHUP • THE SOUNDS • STATE RADIO • STRETCH ARM STRONG
THE SPILL CANVAS • SPITALFIELD • SPLIT FIFTY • SAFETY • SEPTIC TANK DISASTERS • SORRY ABOUT
YOUR COUCH • STARVING GOLIAT • STIGMA 13 • THE STILETTO FORMAL • STRAP-ON TOOLS
STUCKBACKWARDS • SUPER GEEK LEAGUE • SWAK 13 • THE SUNSTREAK • TAKE THE CITY • THIS SOLEMN
VOW • TOKYO ROSE • ULTIMATE POWER DUO • THE UNIVERSITY • VALIENT THORR • VAUX
VOLTERA • VAMPIRE DOLPHIN REPELLANT • VARIETY WORKSHOP • VERBANA DARVELL • VOODOO BLUE
WE ARE THE FURY • WHEELS ON THE BUS • THE YEARS GONE BY • ZEBRAHEAD • ZOX

COLUMBIA, MO • COLUMBUS, OH • MILWAUKEE, WI
MINNEAPOLIS, MN • BONNER SPRINGS, KS • NASHVILLE,
TN • JACKSONVILLE, FL • SAINT PETERSBURG, FL
MIAMI, FL • ORLANDO, FL • LADSON, SC • RALEIGH, NC
ATLANTA, GA • HOUSTON, TX • DALLAS, TX • SAN ANTONIO,
TX • LAS CRUCES, NM • PHOENIX, AZ • SAN DIEGO, CA
POMONA, CA • SAN FRANCISCO, CA • FRESNO, CA
VENTURA, CA • LOS ANGELES, CA • SACRAMENTO, CA
BOISE, ID • GEORGE, WA • PORTLAND, OR • VANCOUVER, BC
CALGARY, AB • SALT LAKE CITY, UT • DENVER, CO
ST. LOUIS, MO • CINCINNATI, OH • PITTSBURGH, PA
INDIANAPOLIS, IN • DETROIT, MI • TINLEY PARK, IL
DARIEN CENTER, NY • FITCHBURG, MA • CAMDEN, NJ
SCRANTON, PA • UNIONDALE, NY • OLD BRIDGE, NJ
CHARLOTTE, NC • VIRGINIA BEACH, VA • BRISTOW, VA
CLEVELAND, OH • BARRIE, ON • MONTREAL, QC

POSTER DESIGN BY BRIANEWING.COM

I got a little grief from people because of the logos on all of the Warped Tour posters.
"I'd like this more if it didn't have the logos on it . . . "
"The logos totally ruined this piece . . . "
Logos paid for the tour. They paid me to draw. The logos help keep the price of admission down so people can afford to
go to the show. They make it easier for the bands to tour and for people to see them.

VANS WARPED TOUR '06
U.S. & CANADA TOUR POSTER • 2006
13" x 19" OFFSET PRINT

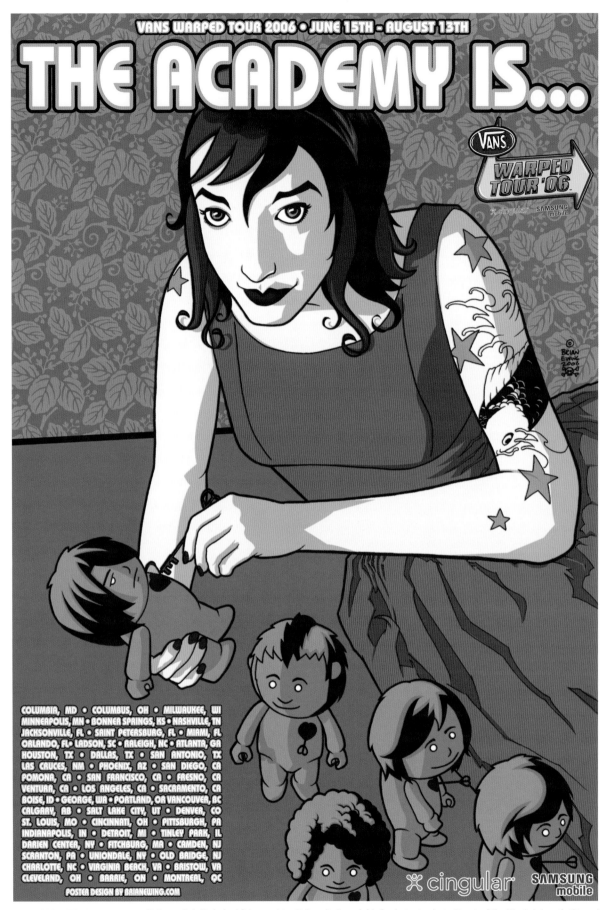

THE ACADEMY IS . . .
U.S. & CANADA TOUR POSTER • 2006
13" x 19" OFFSET PRINT

"Let's say we had a blender that defied space and time. We dropped in the sound of the first electric guitar, the visual intensity of Edvard Munch, the heart of a Rhino, and a dash of sugar, and you get Brian Ewing. His work is more than phenomenal, it captures the spirit of what music is and what it means to people. It doesn't hurt he's a great guy, too."

—Mark Bubb
Atticus Clothing

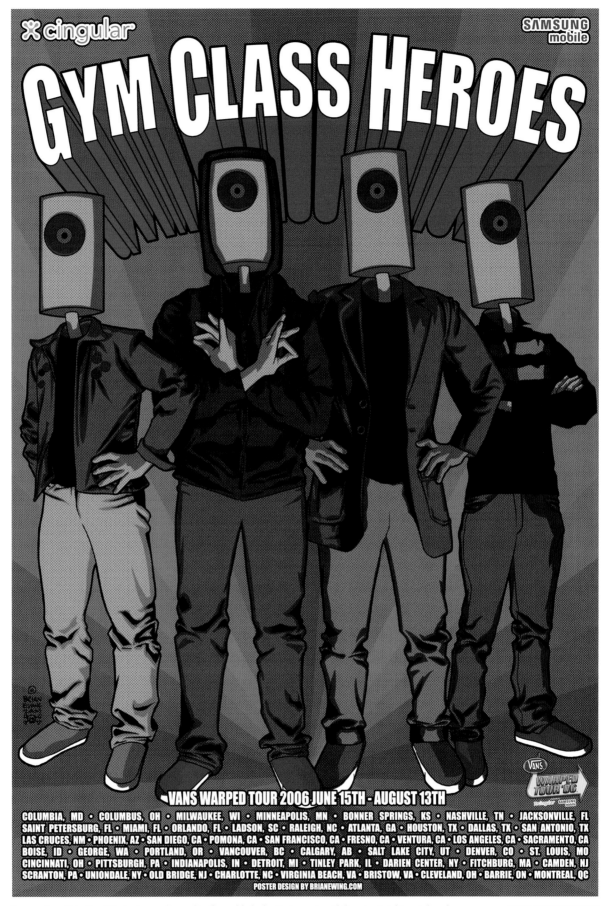

I was on a huge Michael Lau kick when I was working on this. After a while the direction I was going with the poster started to remind me of the old Hanna Barbera *Super-Friends* cartoon I used to watch when I was a kid. "Wonder Twins powers activate . . . " I tried to make the text and background look like the opening title scene (designed by Alex Toth – look him up) from every episode. Useless trivia – I know. I also don't really like doing band likenesses unless I get to shoot reference photos myself. Rarely are they ever done well.

GYM CLASS HEROES
U.S. & CANADA TOUR POSTER • 2006
13" x 19" OFFSET PRINT

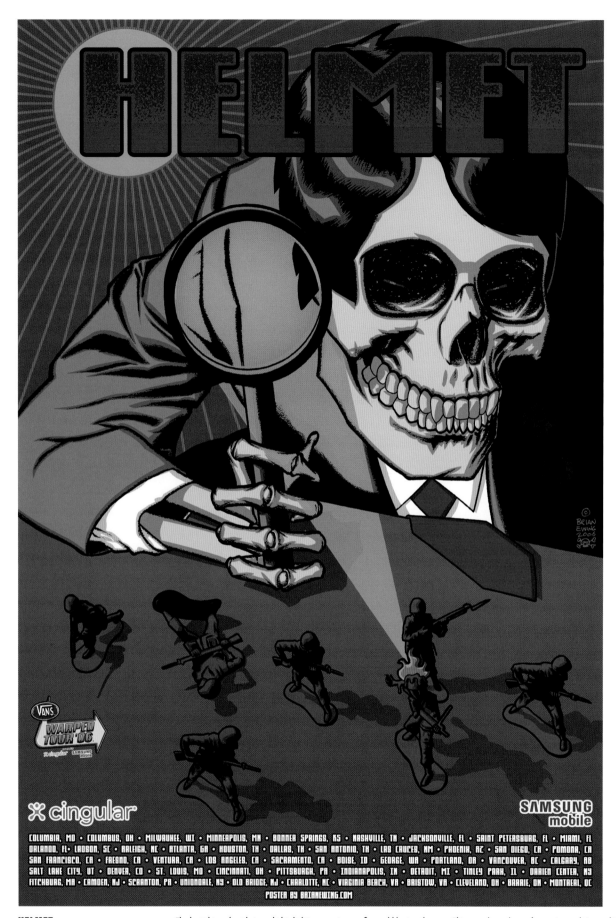

HELMET
U.S. & CANADA TOUR POSTER • 2006
13" x 19" OFFSET PRINT

The best thing about being a kid is lighting your toys on fire and blowing them up. This was also a chance for me to sneak in a political poster. I sent in sketches of a few different ideas and the agency actually went with this one.

Helmet was a favorite of mine when I was younger. All of the poster artists I worshiped (Hess, Kozik, and Coop) had done posters for them and initially influenced me to try the same a decade later. I was stoked to get another chance to do a poster for Helmet. When their album *Meantime* came out, it kicked everyone in the ears — giving us something different to listen to while every other band died out or jumped on the Grunge Wagon.

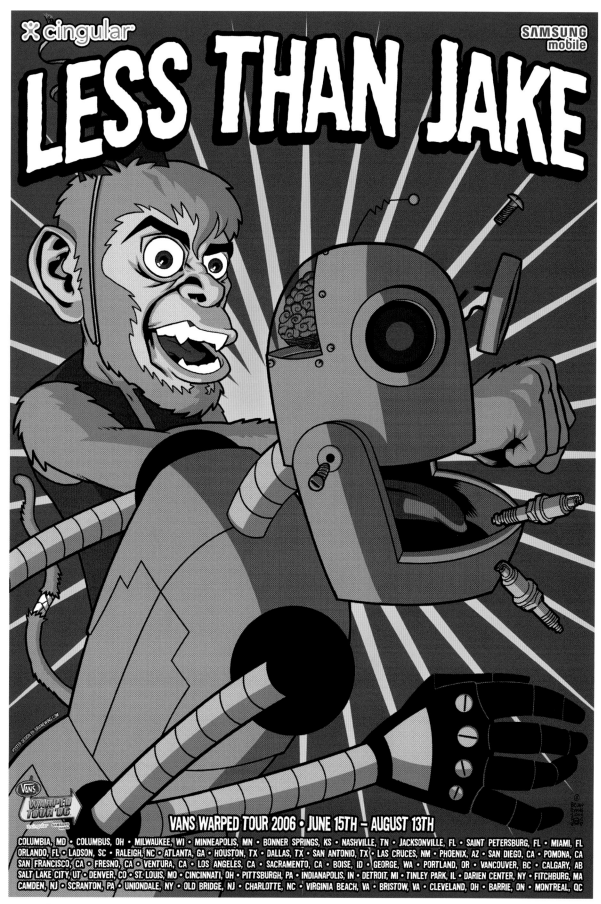

Vinnie Fiorello, drummer for Less Than Jake, also has a toy company called Wünderland War (formerly Monkey vs. Robot). So this was a no-brainer. Monkeys and robots . . . oh yes! This was the year I tried getting more out of Photoshop and Illustrator by actually using more halftones and transparent layers. I tried to get all Geof Darrow/Phil Hale with the robot. Hey, I tried . . . I didn't say I perfected it.

LESS THAN JAKE
U.S. & CANADA TOUR POSTER • 2006
13" x 19" OFFSET PRINT

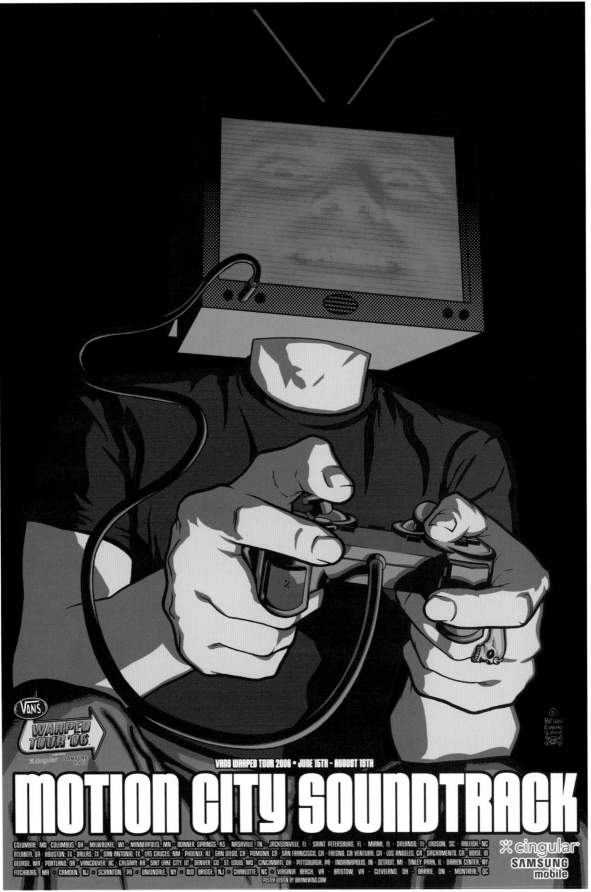

MOTION CITY SOUNDTRACK
U.S. & CANADA TOUR POSTER • 2006
13" x 19" OFFSET PRINT

Inspired by Motion City Soundtrack's song "The Future Freaks Me Out." I'm also taking a stab at my friends (or anyone) who spend too much of their lives playing video games. My buddy Pete Mitchell posed for this. He plays too many video games.

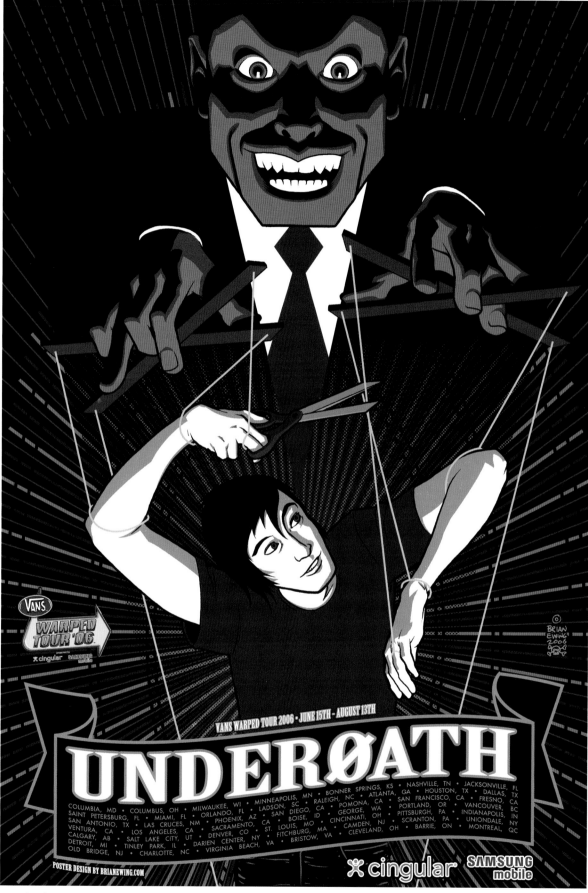

I was poking fun at Corporate Rock.

UNDEROATH
U.S. & CANADA TOUR POSTER • 2006
13" x 19" OFFSET PRINT

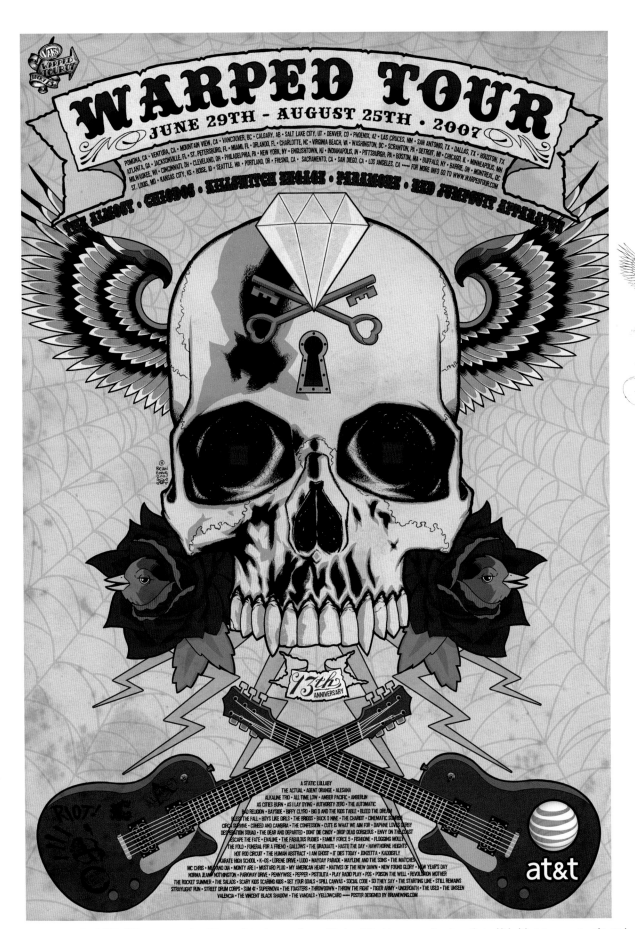

VANS WARPED TOUR '07
U.S. & CANADA TOUR POSTER • 2007
18" x 24" OFFSET PRINT

The 2007 Warped Tour theme was "tattoos." Fuck yeah! Back in my porno days, Larry Flynt published the tattoo magazine *Skin & Ink*, which I handled production on. I busted my ass for this project—geeking out researching the history of American tattoo art and culture. Nothing better than buying a stack of tattoo books and magazines all in the name of "research." Can you say "tax write-off"? I knew ya could. The job called for six posters but the agency only used this piece because of time constraints and budget. (Don't look at me.) On the next two pages you can see a few of the posters that were finished but never used. I still got paid. The other pieces I'm saving for the right projects. Can't let people know how lazy I really am.

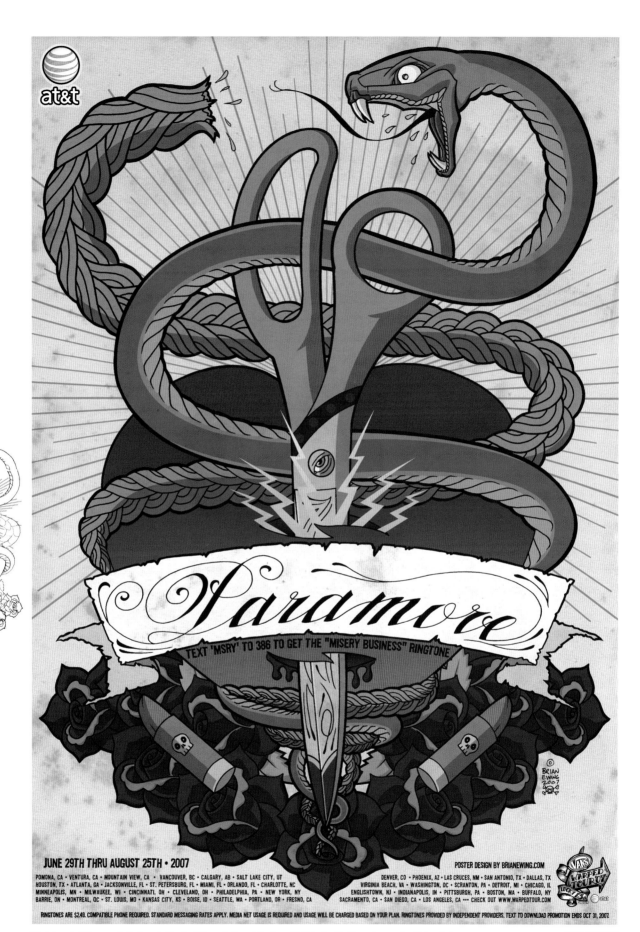

JUNE 29TH THRU AUGUST 25TH • 2007

POSTER DESIGN BY BRIANEWING.COM

POMONA, CA • VENTURA, CA • MOUNTAIN VIEW, CA • VANCOUVER, BC • CALGARY, AB • SALT LAKE CITY, UT
HOUSTON, TX • ATLANTA, GA • JACKSONVILLE, FL • ST. PETERSBURG, FL • MIAMI, FL • ORLANDO, FL • CHARLOTTE, NC
MINNEAPOLIS, MN • MILWAUKEE, WI • CINCINNATI, OH • CLEVELAND, OH • PHILADELPHIA, PA • NEW YORK, NY
BARRIE, ON • MONTREAL, QC • ST. LOUIS, MO • KANSAS CITY, KS • BOISE, ID • SEATTLE, WA • PORTLAND, OR • FRESNO, CA

DENVER, CO • PHOENIX, AZ • LAS CRUCES, NM • SAN ANTONIO, TX • DALLAS, TX
VIRGINIA BEACH, VA • WASHINGTON, DC • SCRANTON, PA • DETROIT, MI • CHICAGO, IL
ENGLISHTOWN, NJ • INDIANAPOLIS, IN • PITTSBURGH, PA • BOSTON, MA • BUFFALO, NY
SACRAMENTO, CA • SAN DIEGO, CA • LOS ANGELES, CA ••• CHECK OUT WWW.WARPEDTOUR.COM

RINGTONES ARE $2.49. COMPATIBLE PHONE REQUIRED. STANDARD MESSAGING RATES APPLY. MEDIA NET USAGE IS REQUIRED AND USAGE WILL BE CHARGED BASED ON YOUR PLAN. RINGTONES PROVIDED BY INDEPENDENT PROVIDERS. TEXT TO DOWNLOAD PROMOTION ENDS OCT 31, 2007.

This is based off Paramore's single and video for "Misery Business." Dealing with high-school bullies and an outdated idea of what kids actually go through as teenagers. I enjoyed working on the art for this one as well. My hand was ready to fall off after inking this thing. This never got printed. So don't email me asking where to find a copy. Buy it off some jackass who's going to cut up this book and sell each page as "mini posters" to unsuspecting suckers. You've been warned.

PARAMORE
U.S. & CANADA TOUR POSTER • 2007
UNPUBLISHED

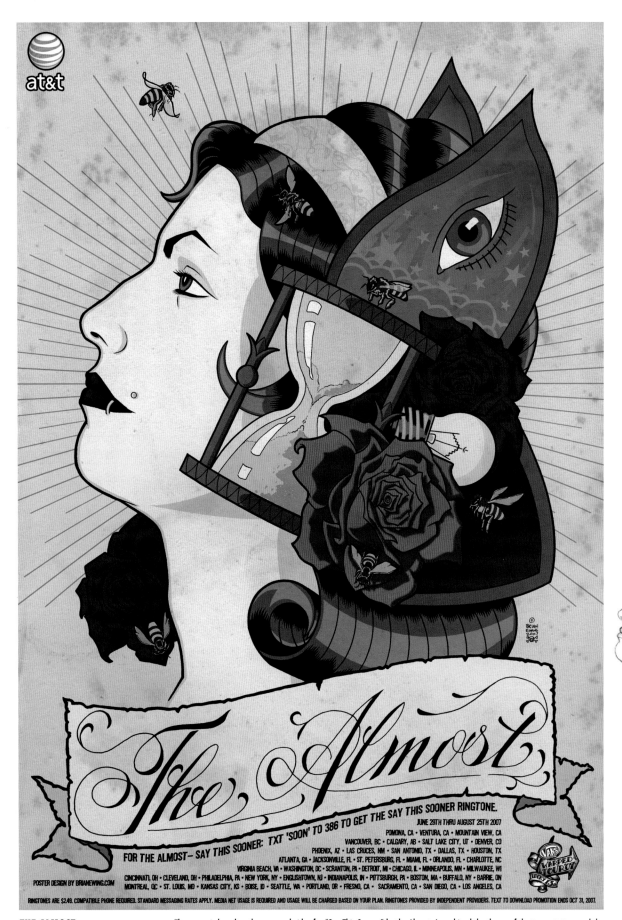

THE ALMOST
U.S. & CANADA TOUR POSTER • 2007
UNPUBLISHED

The poster is based on the song and video for "Say This Sooner" by the Almost. I combined the theme of the tour – tattoos and the theme of the band's video – time travel. I went so far as to do all the band text by hand. Not a strength of mine but I gave it my all anyways. This ended up not getting printed. Grumble grumble.
My friend Rachel posed for this piece. Every time I'm in Sacramento, she and her husband always let me crash on their couch. She also likes to lecture me on the women I date.

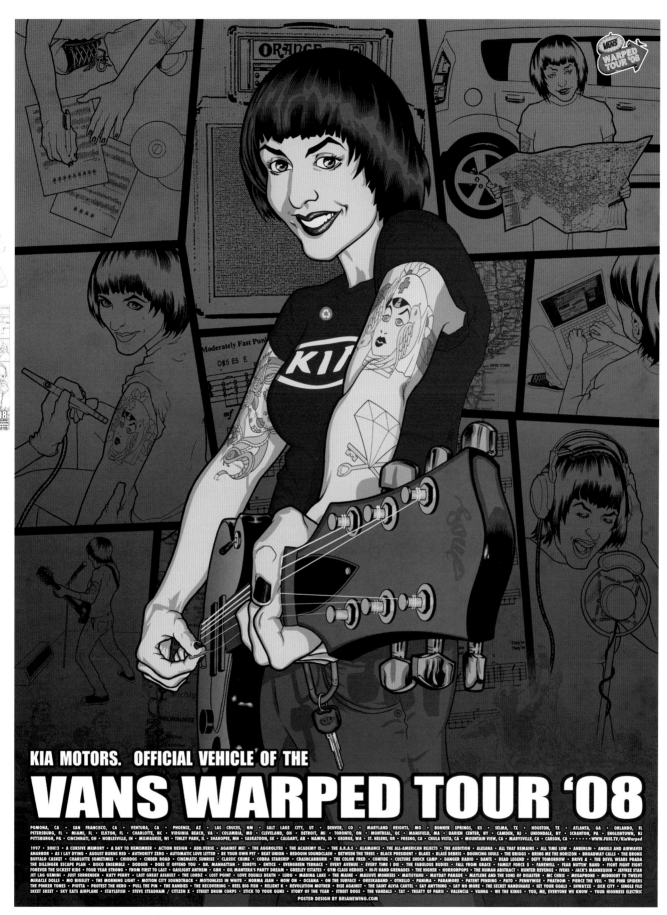

KIA MOTORS. OFFICIAL VEHICLE OF THE

VANS WARPED TOUR '08

POMONA, CA • SAN FRANCISCO, CA • VENTURA, CA • PHOENIX, AZ • LAS CRUCES, NM • SALT LAKE CITY, UT • DENVER, CO • MARYLAND HEIGHTS, MO • BONNER SPRINGS, KS • SELMA, TX • HOUSTON, TX • ATLANTA, GA • ORLANDO, FL
PETERSBURG, FL • MIAMI, FL • ELKTON, FL • CHARLOTTE, NC • VIRGINIA BEACH, VA • COLUMBIA, MD • CLEVELAND, OH • DETROIT, MI • TORONTO, ON • MONTREAL, QC • MANSFIELD, MA • DARIEN CENTER, NY • CAMDEN, NJ • UNIONDALE, NY • SCRANTON, PA • ENGLISHTOWN, NJ
PITTSBURGH, PA • CINCINNATI, OH • NOBLESVILLE, IN • MILWAUKEE, WI • TINLEY PARK, IL • SHAKOPEE, MN • SASKATOON, SK • CALGARY, AB • NAMPA, ID • GEORGE, WA • ST. HELENS, OR • FRESNO, CA • CHULA VISTA, CA • MOUNTAIN VIEW, CA • MARYSVILLE, CA • CARSON, CA • WWW.FUSE.TV/KiaWarped

1997 • 3OH!3 • A CURSIVE MEMORY • A DAY TO REMEMBER • ACTION DESIGN • ADD.VERSE • AGAINST ME! • THE AGGROLITES • THE ACADEMY IS... • THE A.K.A.S • ALAMANCE • THE ALL-AMERICAN REJECTS • THE AUDITION • ALESANA • ALL THAT REMAINS • ALL TIME LOW • ANBERLIN • ANGELS AND AIRWAVES
ANARBOR • AS I LAY DYING • AUGUST BURNS RED • AUTHORITY ZERO • AUTOMATIC LOVE LETTER • BE YOUR OWN PET • BEAT UNION • BEDOUIN SOUNDCLASH • BETWEEN THE TREES • BLACK PRESIDENT • BLAKE • BLASÉ DEBRIS • BOUNCING SOULS • THE BRIGGS • BRING ME THE HORIZON • BROADWAY CALLS • THE BRONX
BUFFALO CASKET • CHARLOTTE SOMETIMES • CHIODOS • CINDER ROAD • CINEMATIC SUNRISE • CLASSIC CRIME • COBRA STARSHIP • CRASHCARBURN • THE COLOR FRED • CONFIDE • CULTURE SHOCK CAMP • DANGER RADIO • DANTE • DEAD LEGEND • DEFY TOMORROW • DRIVE A • THE DEVIL WEARS PRADA
THE DILLINGER ESCAPE PLAN • DISCO ENSEMBLE • DODGER • DOES IT OFFEND YOU • DR. MANHATTAN • EDREYS • ENTICE • EVERGREEN TERRACE • EVERY AVENUE • EVERY TIME I DIE • THE FABULOUS RUDIES • FALL FROM GRACE • FAMILY FORCE 5 • FAREWELL • FEAR NUTTIN BAND • FIGHT FIGHT FIGHT
FOREVER THE SICKEST KIDS • FOUR YEAR STRONG • FROM FIRST TO LAST • GASLIGHT ANTHEM • GBH • GIL MANTERA'S PARTY DREAM • GREELEY ESTATES • GYM CLASS HEROES • HI-FI HAND GRENADES • THE HIGHER • HORRORPOPS • THE HUMAN ABSTRACT • HUNTER REVENGE • IVENS • JACK'S MANNEQUIN • JEFFREE STAR
JET LAG GEMINI • JUST SURRENDER • KATY PERRY • LAST GREAT ASSAULT • THE LORDZ • LOST POINT • LOVE EQUALS DEATH • LUDO • MADINA LAKE • THE MAINE • MASSIVE MONKEES • MATISYAHU • MAYDAY PARADE • MAYLENE AND THE SONS OF DISASTER • MC CHRIS • MEGAPHONE • MIDNIGHT TO TWELVE
MIRACLE DOLLS • MO BIGSLEY • THE MORNING LIGHT • MOTION CITY SOUNDTRACK • MOTIONLESS IN WHITE • NORMA JEAN • NOW ON • OCEANA • ON THE SURFACE • ORESKABAND • OTHELLO • PANIMA • PARAMORE • PATENT PENDING • PATO • PENNYWISE • PHATHOM • PIERCE THE VEIL • THE PINK SPIDERS
THE PINKER TONES • PIOTTA • PROTEST THE HERO • PULL THE PIN • THE RANDIES • THE RECOVERING • REEL BIG FISH • RELIENT K • REVOLUTION MOTHER • RISE AGAINST • THE SAINT ALVA CARTEL • SAY ANYTHING • SAY NO MORE • THE SECRET HANDSHAKE • SET YOUR GOALS • SHWAYZE • SICK CITY • SINGLE FILE
SKEET SKEET • SKY EATS AIRPLANE • STAYLEFISH • STEVE STEADHAM / CITIZEN X • STREET DRUM CORPS • STICK TO YOUR GUNS • STORY OF THE YEAR • STREET DOGS • THE VANDALS • TAT • TREATY OF PARIS • VALENCIA • VANNA • WE THE KINGS • YOU, ME, EVERYONE WE KNOW • YOUR HIGHNESS ELECTRIC

POSTER DESIGN BY BRIANEWING.COM

KIA Motors commissioned me to design their official Vans Warped Tour '08 poster. Fifth tour in a row . . . crazy! I'm just excited to have been hired that many times. They let me pick the theme so I went with a young kid aspiring to play the Warped Tour. I hid a few Ramones references in this one. I drew the girl to look like a Ramone (or "sweet sweet little Ramona"). The sheet music is from "Blitzkrieg Bop" and "I Wanna Be Sedated." My first Ramones album was *Too Tough to Die,* and I bought it at Rushmor Records in Milwaukee, WI — before I could grow a moustache or talk to girls. The Ramones hailed from New York. The maps represent a place I grew up and another place I was about to move to. The crowd shot at the bottom is from a photograph I took at one of the Warped Tour shows. I'm a big nerd.

VANS WARPED TOUR '08
U.S. & CANADA TOUR POSTER • 2008
18" x 24" OFFSET POSTER

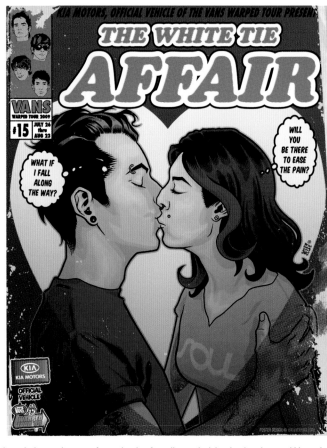

**SCARY KIDS SCARING KIDS
THE WHITE TIE AFFAIR**
U.S. & CANADA TOUR POSTER • 2009
8.5" x 11" OFFSET PRINT

KIA hired me again for the 2009 Warped Tour. This time around they asked me to do posters for two bands. After talking to both bands I thought it would be cool to design the posters to resemble comic book covers. So one was fashioned after the Jack Kirby *Strange Tales* covers. The other was heavily inspired by the old romance comics of the '60s. This was the first time I tried coloring in Photoshop. The learning curve was brutal but worth it. I normally do all of my coloring in Illustrator.

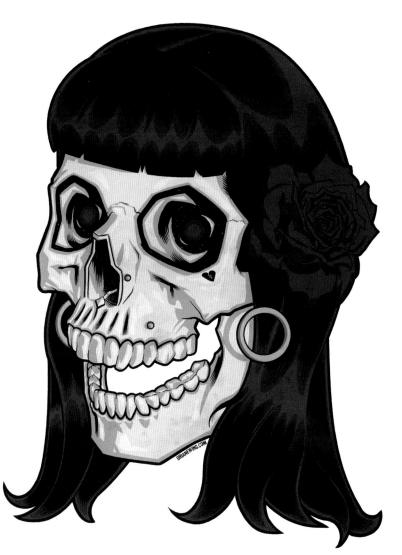

2009 WARPED TOUR
LOGO AND COLLATERAL ARTWORK
U.S. & CANADA TOUR • 2009

For the 2009 Warped Tour I had the awesome opportunity to work with KIA again and also design the logo and collateral artwork for the tour itself. I'm very grateful to have worked with the tour so many years in a row.

I designed the skulls to represent the type of people I've seen attend the shows. There's always the Emo kid. The older punk rocker that I might've sorta styled after Milo from the Descendents. Adding the coffee tear drop tattoo to further my love for the band (and coffee). The Rockabilly Bettie Page girl. I'm a sucker for girls with the Bettie Page bangs. Finally the main skull would embody the spirit of the tour with the candle mohawk. Count the candles. Also a nod to Pushead and the artwork he had done for the Exploited.

Once the job was done I was thinking about sleep or food or the next job. I didn't expect to see the logo and skulls everywhere. I mean EVERYWHERE. Wahoo's Fish Tacos released a limited-edition cup (and were cool enough to put my URL on it)! It was like having my own Burger King *Star Wars* glass! FUSE TV featured the art on their weekly Warped Wednesday show. AT&T wrapped their tour bus, designed their booth with the art, and even went as far as to make sculptures representing each of the skulls that sat on top of the booth. I saw kids walking around with the skulls drawn on skate decks and shirts they had made with markers. That was rad!

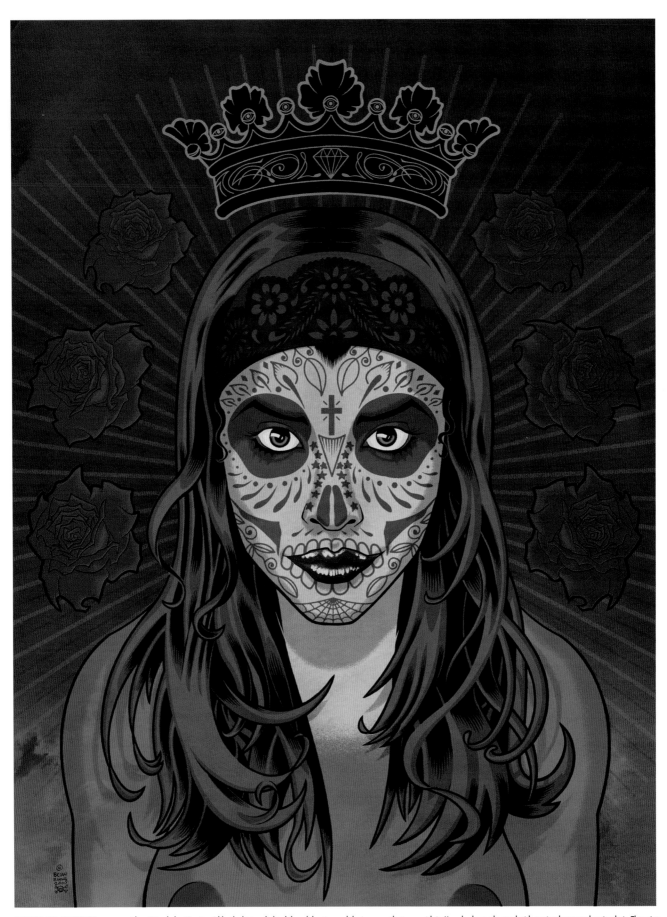

HASTA LA MUERTA
18" x 24" GICLEE PRINT
EDITION OF 25

I love Dios de los Muertos. I like the history behind the celebration and the imagery that goes with it. I've also been obsessed with getting better at drawing hair. The print was made for Harley-Davidson's *Art of Rebellion* show that I participated in.

This was originally designed for *Royal Flush* as centerfold calendar for their 2009 Hugh Hefner issue. I cropped it for the art print. If you wanna see the goods (the rest of her), then I suggest picking up that issue of *RF*.

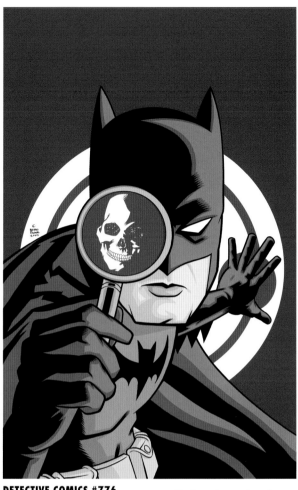

DETECTIVE COMICS #776
COMIC BOOK COVER • 2002
©DC COMICS

"Though I'm still somewhat bitter that Brian Ewing fled the Midwest in favor of the wrong end of California so many years ago, I am at least glad that he managed to wreak havoc on the West Coast poster design scene. Who would have guessed that the quiet kid from the neighborhood Kinko's would ever make out so well? His rise to power in the City of Angels is even more remarkable if you consider that he doesn't even drive! I guess some people DO walk in L.A."

—Michael Drivas
Big Brain Comics

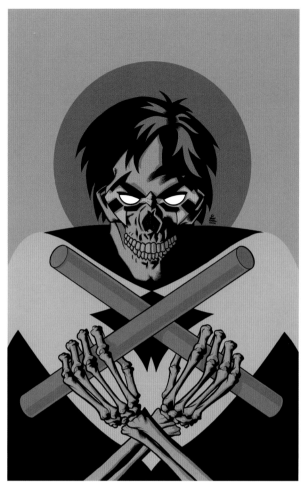

NIGHTWING #78
COMIC BOOK COVER • 2002
©DC COMICS

Yep, I got a chance to draw a few covers for DC COMICS! It's the same process as designing and drawing a poster, so I had a lot of fun working on them. Definitely a high point for my career. Hopefully I'll get to do more.

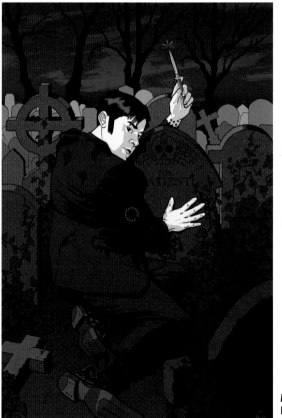

MY CHEMICAL ROMANCE
POSTER INSERT • 2007
ROYAL FLUSH MAGAZINE

SKIN & INK
MAGAZINE COVER • 2004
FLYNT PUBLICATIONS

"Brian is the consummate artist; he is my peer and the closest thing to a mentor I've ever had, and while I do tower over him physically, I look up to him like no other."

—R.Black
aka Dick Negro
aka Erbal Ack
Rock Poster Artist

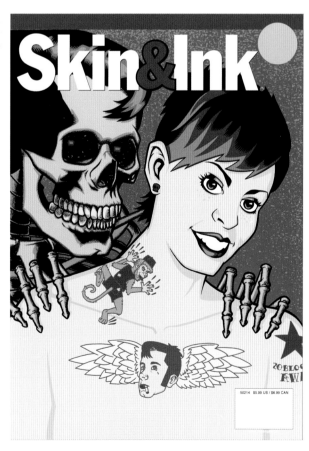

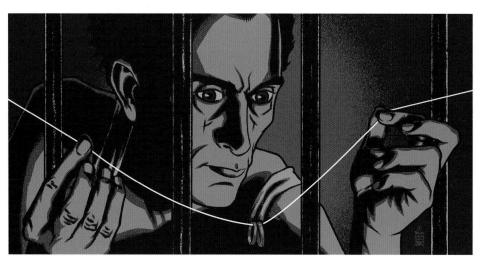

"Ewing's brilliantly ghoulish themes and inhuman control of the line has guaranteed his position among the *Deviant Gods*."

—Scrojo
 Rock Poster Artist

Steve Chanks art directed this project as a way to help raise money for the only hangout rock-poster designers and collectors congregate – gigposters.com.
The calendar was screen printed and sold out within a day.

To see a tutorial on how I put the drawing together, check out my website.

MS. FEBRUARY
CALENDAR • 2008
GIGPOSTERS.COM

JO-JO AND THE FIENDISH LOT
BOOK COVER • 2007
HARPER COLLINS

Harper Collins hired me to illustrate this cover to Andrew Auseon's book *Jo-Jo and the Fiendish Lot*. This is my first book cover . . . and it's got a skull on it! Oh yeah!

INGRID MICHAELSON

EDITORIAL ILLUSTRATION • 2007
© *THE NEW YORKER*

Jobs like this usually have a short deadline of a few days and end with me pulling an all-nighter. Ingrid's management dug the illustration.

"Brian has a very recognizable way of illustrating expression and feeling. His posters are super colorful, crisp, and well thought out. Top notch!"

—Clay Hayes
gigposters.com

JOKER

GP DECK OF CARDS #3 • 2007
GIGPOSTERS.COM

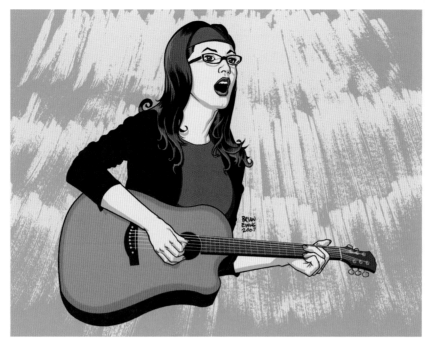

"Brian's work is a graphic blast of appetizing women and figures ranging from shady, to outright deranged. It's all beautifully composed and arrests the eye with force."

—Max Bode
Art Director
The New Yorker

GRINDHOUSE

EDITORIAL ILLUSTRATION • 2007
©THE NEW YORKER

This was fun to do. The movies weren't released yet, so I had to scour the Internet for any and every bit of reference for the movie.

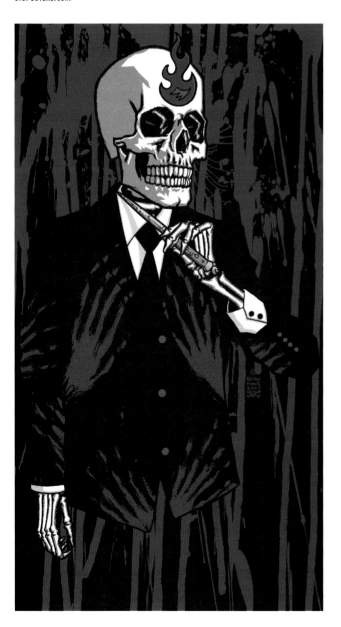

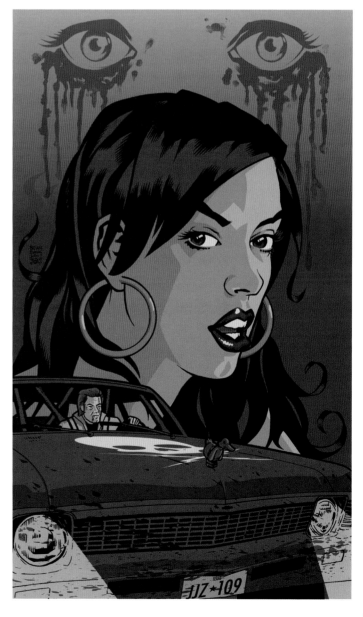

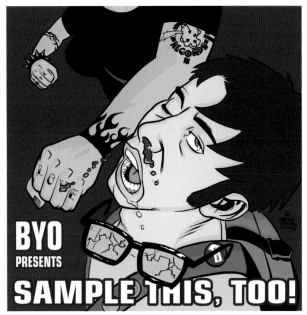

BYO: SAMPLE THIS 2
CD COVER • 2001
BYO RECORDS

Thanks to the Stern Bros. for hiring me to do this cover. This was my first freelance gig after quitting the porno job. Some of my favorite bands, including Bouncing Souls and NOFX, are on this.

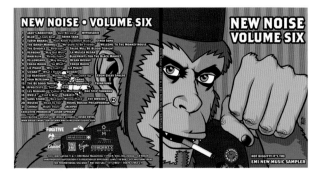

NEW NOISE VOLUME 6
CD COVER • 2002
EMI RECORDS

CD cover and layout for EMI. This was a lot of fun to do, and they gave me free reign to go "apeshit." This is actually the uncensored version. Best Buy wouldn't carry the CD with a monkey smoking a cigarette on the cover.

ROCK-N-ROLL AU-GO-GO VOL.6
CD COVER • 2001
DEVIL DOLL RECORDS

"I love Brian's work! I asked him to do our CD art because I'm a big fan of his artwork. He previously worked on a poster for us that included the Original Sinners and another poster for us where a woman was knocking out a fella's tooth. I thought, "This guy gets it. He has mental problems too!" Ewing is one of the few artists who gives you exactly what you want and knows how to put a face on a project. When people think of Three Bad Jacks they will think of Brian's Image."

—Elvis Suissa
Three Bad Jacks

CRAZY IN THE HEAD
CD COVER • 2005
THREE BAD JACKS

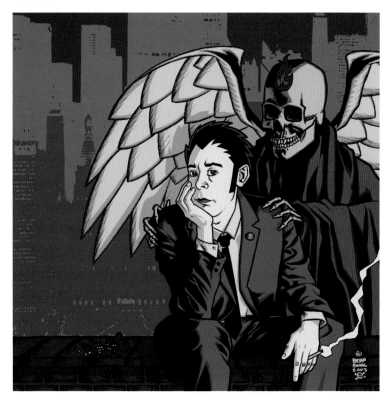

Only 1000 copies were pressed, and I think they sold out within an hour or two. They only charged their fans for shipping and that's it! It's a great gesture from the band to their fans. I wish more bands did this . . . and hire me, too . . . nudge nudge. Good luck trying to find them. I don't have any for sale . . . so don't ask. Solly Cholly. Check eBay . . . they tend to go for $75-$300 a pop.

THE HOLIDAY EP
CD COVER • 2004
BRAND NEW

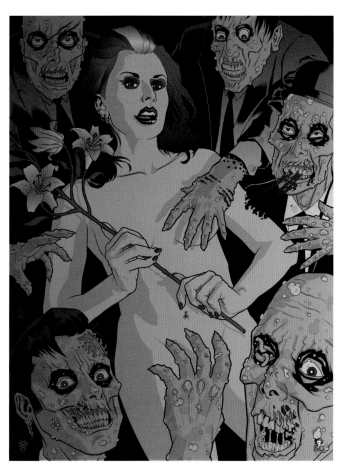

MEOW SUICIDE
SD COMIC-CON
EXCLUSIVE
2008
18" x 24" OFFSET
EDITION OF 300

"Brian's art is the cat's pajamas — yes, pun intended. His style is bold and eye catching, and it's always a bonus when the artist is actually rad in person. I'd sit at a table hungover with him anytime."

—MEOW Suicide
suicidegirls.com/meow

MEOW SUICIDE
PENCIL STUDY • 2008
GRAPHITE ON RIVES BFK

KILL AUDIO
NY COMIC - CON EXCLUSIVE POSTER • 2008
18" x 24" SCREEN PRINT
UNSIGNED EDITION OF 250
SIGNED EDITION OF 50

STAF #17
MAGAZINE COVER • 2003
STAF

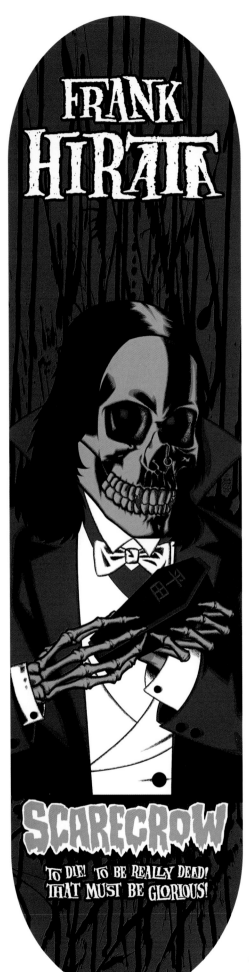

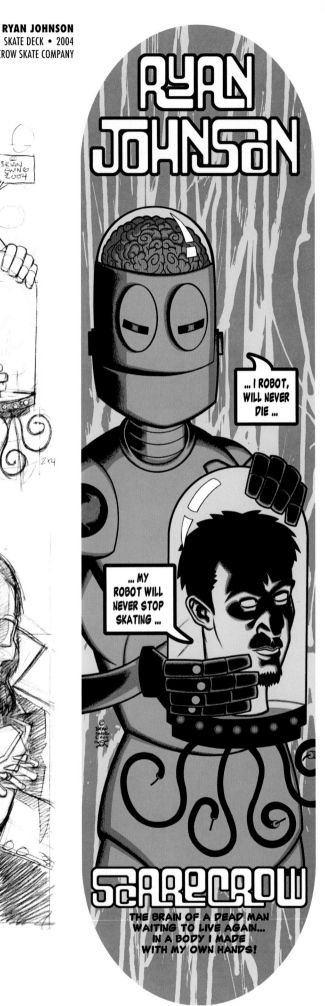

FRANK HIRATA
SKATE DECK • 2004
SCARECROW SKATE COMPANY

PAPER ZOMBIE MASK
FREE GIVEAWAY • 2007
8" x 10.5" DIE-CUT OFFSET PRINT
©FEARNET.COM

This was commissioned by Fearnet.com to be handed out as a paper zombie mask at major video and electronics stores throughout the United States. Fearnet is a horror movie channel and website. I'm stoked that I got to do something for them. Somebody paid me to draw a zombie!!

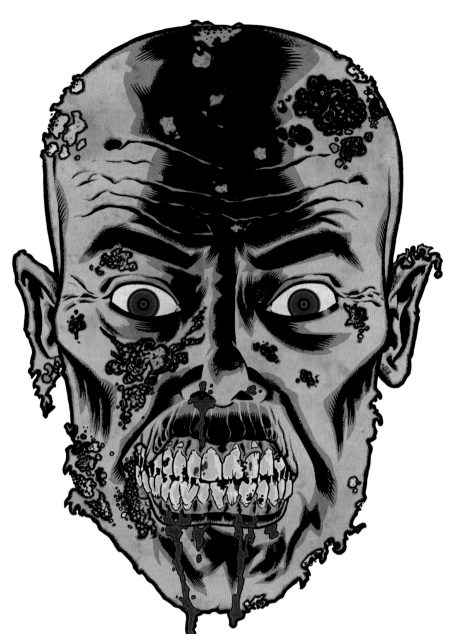

PAPER ZOMBIE PUPPET
PUPPET • 2008
CREATED FOR NORMA V. TORAYA'S BOOK
PAPER PUPPET PALOOZA

"One and one is two, and two and two is four, and five will get you ten if you know how to work it." —Mae West

"That's Brian in one of his many nutshells. He doesn't even bother shoving himself into a buxom frilly corset to live it, either.

"Those close to Brian know about how hard he works. The lack of sleep, multiple tight overlapping deadlines; his festively littered Dorito bag workspace diorama and enduring cabin fever make certain folks assume he's some sort of mutant hermit crackhead. He's not. He works and he'll fight and he hussles — all in the name of his art.

"When I asked Brian to test his secret arty ninja skills by making a puppet, I thought, 'No big woop, right?' There was a part of me curious to see him work on something completely different. I had no doubts, but he took on the puppet challenge with the typical hardcore panic he applies to all his posters. That's right, he completely freaked out and then got to work."

—Norma V. Toraya
Animator
Donut Genie

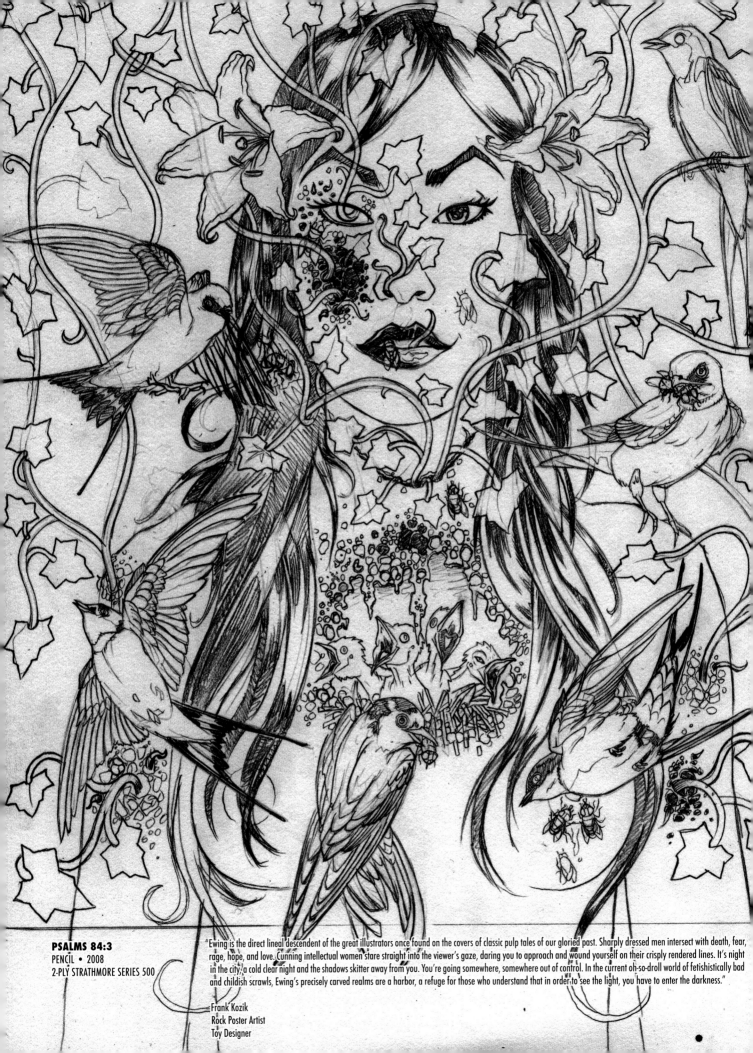

PSALMS 84:3
PENCIL • 2008
2-PLY STRATHMORE SERIES 500

"Ewing is the direct lineal descendent of the great illustrators once found on the covers of classic pulp tales of our gloried past. Sharply dressed men intersect with death, fear, rage, hope, and love. Cunning intellectual women stare straight into the viewer's gaze, daring you to approach and wound yourself on their crisply rendered lines. It's night in the city, a cold clear night and the shadows skitter away from you. You're going somewhere, somewhere out of control. In the current oh-so-droll world of fetishistically bad and childish scrawls, Ewing's precisely carved realms are a harbor, a refuge for those who understand that in order to see the light, you have to enter the darkness."

Frank Kozik
Rock Poster Artist
Toy Designer